WHEN
THE MUSEUM
IS CLOSED

Also by Emi Yagi

Diary of a Void

WHEN THE MUSEUM IS CLOSED

Emi Yagi

TRANSLATED FROM THE JAPANESE BY
YUKI TEJIMA

HARVILL

1 3 5 7 9 10 8 6 4 2

Harvill, an imprint of Vintage, is part of the
Penguin Random House group of companies

Vintage, Penguin Random House UK, One Embassy Gardens,
8 Viaduct Gardens, London SW11 7BW

penguin.co.uk/vintage
global.penguinrandomhouse.com

Penguin Random House UK

First published by Harvill in 2025

Copyright © Emi Yagi 2023
English translation copyright © Yuki Tejima 2025

The moral right of the author has been asserted

First published in Japan with the title 休館日の彼女たち
(*Kyukanbi no kanojotachi*) in 2023 by Chikumashobo Ltd., Tokyo.
This English edition arranged with Chikumashobo Ltd. through
The English Agency (Japan) Ltd. and New River Literary Ltd.

Penguin Random House values and supports copyright. Copyright fuels creativity, encourages diverse voices, promotes freedom of expression and supports a vibrant culture. Thank you for purchasing an authorised edition of this book and for respecting intellectual property laws by not reproducing, scanning or distributing any part of it by any means without permission. You are supporting authors and enabling Penguin Random House to continue to publish books for everyone. No part of this book may be used or reproduced in any manner for the purpose of training artificial intelligence technologies or systems. In accordance with Article 4(3) of the DSM Directive 2019/790, Penguin Random House expressly reserves this work from the text and data mining exception.

Typeset in 13.05/18.75 pt Garamond Premier Pro by Six Red Marbles UK, Thetford, Norfolk
Printed and bound in Great Britain by Clays Ltd, Elcograf S.p.A.

The authorised representative in the EEA is Penguin Random House Ireland,
Morrison Chambers, 32 Nassau Street, Dublin D02 YH68

A CIP catalogue record for this book is available from the British Library

ISBN 9781787304642

Penguin Random House is committed to a sustainable future
for our business, our readers and our planet. This book is made
from Forest Stewardship Council® certified paper.

MIX
Paper | Supporting
responsible forestry
FSC® C018179

WHEN THE MUSEUM IS CLOSED

There she stood. A goddess. In the octagonal room, nimbly curving her full figure.

'Um, hello.'

'You're here. Welcome.'

Her voice was surprisingly husky. Somewhere between a mezzo-soprano and an alto, though leaning more towards alto if I had to choose. If she were singing in a choir, that is.

I started to give her my invitation, but the curator swiped it from my hand and held it up for her to see. I froze. What was I thinking? That I could simply pass it to her? But the goddess didn't appear to be bothered. After a pause, she opened her mouth.

'Rika Horauchi. May I call you Hora?'

I nodded. Her declaration of a new nickname caught me off guard, but I also didn't have anything I would rather be called. The goddess squinted her pupil-less eyes.

'And I want you to call me Venus, not Aphrodite. I know I'm very "ancient Greek goddess", but I was born in Rome, see. Though Venus is actually my English name.'

I nodded for the second time. Her eyes twinkled, her engraved smile stretching as wide as it could go.

'Terrific. Now tell me, do I speak too fast? I don't sound too different from what you learned in school, do I? I hope you'll tell me if I do.'

'No . . . I can understand you very well,' I replied gingerly as I rubbed my palms against my raincoat. I was sweating profusely.

'I'm glad. I come from a time when nobody could have imagined the Roman Empire ever dividing, before Latin splintered into Italian and French and what have you.'

Venus cackled. Her bare white shoulders and smooth torso, wrapped in a layer of soft flesh, didn't budge. Perhaps there was a rule about bodies made of marble not moving from the neck down.

*

The conditions of the part-time job weren't bad. They just weren't the sort of conditions you came across every day.

The person who'd recommended me for the position was a professor with whom I'd taken a class at university. I hadn't been back in years. I arrived at the train station by the university, scurried past the roundabout, which could only be described as forest-fire-level chaos, ambled through the gates and up the hill past girls dressed in matching outfits – pyjamas? – into a north-wing laboratory where a tattered light green carpet jumped out at me. I was gazing at the expressionless pile carpet as it absorbed the new-student cheers from the courtyard, when an invitation was thrust in my face. An envelope emblazoned with the university name. I glanced up and locked eyes with a face I recognised.

I accepted the envelope with both hands but kept them hovering.

'I'm sorry. I'm just not sure I have what it takes.'

'I can't think of anyone more qualified than you. No one alive, at least.'

The professor looked as though he were addressing somebody behind me.

'Think of it as a tutoring job. Except that it's easier. All you need to do is talk.'

'But she is something of a heritage speaker, and—'

And when you say *talk* ... But my next words slipped soundlessly to the ground before the yellow

vinyl material, like the final sprays of a park fountain at closing time. As I breathed in and out, puckering my lips in search of an excuse, the professor started to hop on one foot as if he'd got water in his ear. He turned to the mirror to straighten his jacket, and I took that as a sign that our discussion was over. Time to show myself out. I headed towards the exit and spotted the pyjama girls again, this time perched on a bench by the main gates nibbling on matching sandwiches.

The museum was some distance away by bus. Walking from the bus stop towards my destination, all I could see were magnolia flowers and the houses and shops buried under their bone-white petals. Checking and double-checking the professor's map, I arrived at last at the building I'd been searching for. The bronze doors and concrete walls with remarkably few windows looked ancient, and the building more closely resembled a student dormitory awaiting demolition than an institution where precious cultural assets from around the world were collected and stored. Passing a sign that read *Museum Closed Today*, I found the back door and took out my phone to call the number I'd been given. The door swung open on the second ring, and I was quickly ushered inside. Like a members-only party.

Except this party didn't seem to be welcoming

visitors. Especially those who were alive. It was as frigid as a morgue inside – perhaps to protect the art – and the floors and walls reeked of seeped-in chemicals. The chandelier fixed squarely in the vaulted ceiling and the elegant milk glass lamps that lined the hallway cast their soft gazes downward. Strolling past glass display cases of fossils and earthenware artifacts, my eyes landed on a rack by the main entrance with flyers advertising children's events and local flea markets. Were these events real? Did the dates and times printed on these sleepy flyers arrive at some juncture somewhere in the world, and did children really congregate to do science experiments? Did people lay out their used sweaters and second-hand audio equipment, hoping someone would claim them?

In my line of vision, where everything appeared faded and frozen in time like a page out of an old calendar, the only evidence of life was the curator walking in front of me.

'Watch your step.' He turned to me, as though he knew I would catch my hem on the stairs. The curator's name was Hashibami, and he was astonishingly good-looking. I couldn't tell his age, but he looked stylish and youthful in a white shirt and slim-fitting trousers, and his beauty struck me as that not of a human being, but of a piece of craftwork – perhaps

a vase, or lacquerware. I gripped the invitation inside my pocket. Handsome men made me uncomfortable. Particularly handsome men who were kind – or appeared so, anyway.

The doors opened at the top of the stairs, and I was drawn instinctively to the arched windows. If there was an argument for light having a gravitational pull, I would have to agree wholeheartedly. Though not visible from the outside, the centre of the building had been hollowed out to make room for trees and a small pond, with a curved corridor above – awash with translucent light – that provided a full view of the quaint courtyard. Pointing out the bouquet reliefs on the pillars, Hashibami explained, 'We're standing in the former mansion of a wealthy man who lived in the area and donated this building to the museum. The upper floor houses the collections he amassed over the years, though the doors are closed to the public today.'

A symphonic melody floated out of one of the galleries. I recognised the smooth, uplifting swell of an oboe, and timpani rolls that made me think of excavating old memories with a wooden mallet. Strolling past a door embellished with seashell carvings, I could almost smell the balmy salt air, hear the lapping of the sea. This was a side to the museum I'd not known

before; a day of private celebration behind closed doors.

We were headed for a room at the end of the hall. Hashibami chose a key from a heavy bundle and inserted it into the door, unlocking it with a click. I peeked through the crack, ignoring the faint reflection of a yellow raincoat in the hallway window.

'Right this way.'

This was to be my new workplace, apparently. My shift was once a week, and no experience was required aside from conversation-level Latin. I had been hired to talk to the ancient Roman statue of Venus.

*

I glanced around the room once more, moving only my eyes so as not to seem obvious.

The room was a snapshot of ancient mythology. Light streamed in from the domed skylight, illuminating the goddesses positioned around the room like constellations. Hera was glaring in my direction, Diana stood tall with her hunting dog, and there was Minerva, adorned in armour. Eight goddesses from Greek and Roman myths. From their bloodless white lips I could make out the sounds of ancient Greek – or perhaps it was a different language – weaving lace

designs in the air to pass the time. At the far end of the octagon, beyond the shadows created by the overlapping banter, stood Venus.

'Oh, hello,' she spoke up. In contrast to her frozen shoulders, her jaw moved in one fluid motion. 'Hashibami, bring Hora a chair, will you? We mustn't keep her standing like this.'

The curator walked to the corner of the gallery to retrieve a chair likely reserved for the security guard during open hours. He brought it over and was about to resume his position next to the goddess when she continued in her smooth alto tone, 'Thank you. You can go now.'

'But—' His Latin betrayed a touch of urgency.

'Don't worry. I'll call you if I need you,' the goddess reassured him. 'And close the door, will you? All the way.'

Hashibami gave me a once-over and headed towards the exit, where he bowed slightly and shut the door. As the clacking of his shoes grew distant, the goddess said, 'Have a seat.' I sat down and raised my eyes, only to avert them just as quickly. I was staring right into her downward gaze.

She was the goddess of love and beauty indeed. Her voluptuous figure arched into a magnificent S-shape, and her smile was both exquisite and meticulously

spared of all characteristics that make a face unique. She had neither laugh lines nor crow's feet, and the touch of resignation on her joyous, symmetrical face only accentuated her heavenliness. Her gown, cascading in gentle folds designed not to sway, had no intention of veiling her physique as a garment is wont to do, covering neither her full breasts nor her round bottom. Feeling self-conscious, I fidgeted in my own body – with no curves or undulations to speak of – and the goddess asked, 'Is your chair comfortable?'

'Yes, it's great,' I replied without thinking, putting on my best first-impression smile. My answer didn't seem to satisfy her. She asked again in a tone one might use when checking the pockets of a child who's been caught stealing. 'Hora, is the chair comfortable?'

'Yes, it is.'

'Honey, did you attend a school that taught you to speak using the minimum number of words possible? Tell me now, is that chair really comfortable? For you.'

I considered the depth of the seat for the first time. I then focused on the position of my spine and the distance of my heels in relation to the floor, one by one, as though I were tracing an X-ray with my finger.

'The seat might be a little high.' Worrying that my answer was still too brief, I added, 'Because I have short legs.'

'Thank you for sharing a little about yourself with me. I don't know what it's like, since I've never sat in a chair. Okay, ring the bell there and call Hashibami back, will you?'

I scooted as directed towards a windowsill and found a small golden bell, which I rang timidly.

Those lips, which had never known dryness or cracking, rippled once again. 'Now, I don't know very much about the length of your legs, but there's no need for negative self-talk.'

The goddess smiled. My body stiffened. Like a statue.

Footsteps drew closer and the door opened, and Venus instructed the curator to bring a new chair. She thanked him for his attentiveness and specified the size of the chair he was to bring. She would make an excellent boss – if she were ever to work outside of the museum, that is.

Once the door closed, she waited a beat to speak again. 'Thank you for coming today. Your Latin really is wonderful. When Hashibami reached out to your professor for recommendations, your name came up right away. He said you were excellent.'

'Oh no, that's not true,' I breathed out, hoping to avoid those white eyes.

'I'm saying it because it's true,' she said smoothly.

'You graduated from university and . . . are you in grad school now?'

'Grad school? Oh no, um, I just do various, uh, tasks . . .' I tried to find the words before they slipped out of my reach. But the harder I tried to chase them down, the more elusive they became, vanishing into thin air or tumbling sadly to the floor.

I went silent, inside my raincoat. A small part of me hoped I would be fired from the job. But Venus only murmured, 'Tasks are nice,' and started to explain what my work would entail.

It was just as the professor had described. Every Monday, when the museum was closed to the public, I was to come here and converse with Venus. If Monday fell on a national holiday, meaning it was open to visitors, I was to come the following day. The transportation fare to and from the museum would be covered. The trial period was three months.

'If you need to take a day off, just try to give us at least two days' notice. Unless you suddenly come down with something or the weather keeps you home, of course.'

I nodded. I thought about the tutoring gig I'd had for six months in college where the parents of the elementary-school-age child I was teaching had insisted on punctuality, and how once, when the trains

stopped due to snow, I had to transfer frantically from bus to bus in order to make it to the house on time. When I arrived, I had no feeling left in my wet, frozen toes. I rang the doorbell and the mother said to me airily, 'I think I'm going to let him play in the snow today,' and asked to reschedule. I watched the child and his golden retriever in matching posh Montbell down jackets scamper around their snow-covered front yard, which was the size of two tennis courts. Compared to that flop of a job, this position was a dream. The goddess didn't seem the type to reschedule because of the weather. Or the type whose marble legs would ever step off the pedestal.

And yet, I continued to search for reasons to quit. I felt out of place here. The goddess was breathtaking and much too exposed, and I, on the other hand, wore too many layers. Always.

I wiped the beads of sweat off my forehead. The yellow hood fell over my head and covered my eyes.

Venus gave a small yawn. 'Hora,' she murmured in her alto tone. 'Are you a deep sleeper?'

'Average, I think,' I answered, my eyes on the ground. I wanted to avoid seeing her perfectly symmetrical mouth distort in any way, if possible.

'Oh, you're lucky. I'm such a light sleeper. If I had a stomach, the first thing I would do is take sleeping

pills. Enough of them so I would never have to wake again.'

I looked at her museum label for the first time.

*Aphrodite of Paliano / Reproduction of
Greek statue by Roman sculptor /
1st to 2nd Century*

A dizzying amount of days and nights, of immeasurable dust and body heat, had passed over the span of two millennia. The years had given the nude goddess an elegance no ornamentation ever could, and at the same time, wrapped her in the kind of solitude no one could fathom.

Footsteps approached on the other side of the door. 'Hora,' Venus lowered her voice as if trying to shield the glow of candlelight from a monster. 'No painting or sculpture in the world can compare to the beauty of a single night's dream. Think about it. You get to become someone else, go somewhere different. Dreaming is the only way I can manage to escape the endless stretch of time that lies ahead of me.'

Would you like to join me? she joked, her playful tone grazing the bare skin under my coat. The meaning of those words was lost on me.

Hashibami returned with a chair as well as an

employment contract, which I found myself signing on the spot. I would be paid via bank deposit on the tenth of every month.

*

Oh, someone just crossed.

I stopped to watch. The bridge, visible from my apartment's rusty staircase, reminded me of tiny sardine bones, and I rarely saw anyone cross it. As I stood and squinted into the distance, the frosted glass window on the floor below me slid open a crack. I inhaled from the gap in my hood, taking in the aroma of homemade cooking but also something else – a fragrant warning.

I had signed a lease for this apartment as soon as I found it. The dilapidated two-storey building stood out in a neighbourhood lined with small factories. The rooms could not possibly get less sunlight, but rent was cheap, and the white walls covered in ivy could be described as having character. The toilet and bathtub were in separate rooms – the toilet even had a bidet function – and the kitchen came with two stove burners. The apartment had a landline, though I didn't know why.

What I hadn't expected to get in the deal was the

landlady. Not just as the building owner to whom I would be paying rent, but as a regular fixture in my life.

I dashed back down the stairs towards the unsettling odour. The door was unlocked, and I swung it open. I stepped over the cardboard boxes that had piled up by the entrance, and ducked through the beaded curtain to find Seriko peering into a pot in a kitchen that smelled year-round of simmered onions. Next to her, an oven mitt with crispy burn marks was about to morph into a flame.

'You're home. School today?' Seriko turned, her body like a glass figurine.

Stumbling over my yellow hem, I threw the burning oven mitt into the sink and turned on the tap. Water splashed everywhere, leaving only a charred smell. Seriko stared at the sink as though she were watching an elevator go right past her floor, then repeated, 'School?' I had graduated university years ago, but in her mind I was and would always be a student.

'I started a new part-time job, in addition to the other one,' I replied, scanning the kitchen table. A phone book, round bolo cookies, milk, a knitted hat. The milk had expired four days ago.

Seriko widened her light eyes and said in a higher

pitch than usual, 'Right, right. New job. Miss Rika talking to Miss Goddess. In Greek. So smart.'

'It's Latin,' I corrected her, knowing it was pointless. When she looked away, I poured the milk down the drain and ran the tap again. The white liquid swirled into a marble pattern before shaping up into a line.

'Smart. So smart. Russian? I could never.'

Her hearing is going. Actually, it's not just her hearing, her niece had said as she eagerly placed the apartment keys in my hand, freed from the responsibility of caring for her ageing aunt. Seriko, who had stood next to her grinning, was now the responsibility of the new tenant, who had been lured by the cheap rent.

The day after I moved in, my apartment phone burst into life. I was the new social services helpline. And Seriko made great use of me.

'Hello, I bundled up old newspapers but can't take them out. My back, you see.'

'I'm going to hospital for check-up. What are bus times in nine o' clock hour?'

A month into living here, I learned that the ivy covering the apartment had originated on Seriko's balcony, where the bitter melon she was growing had spiralled out of control.

Seriko stared wondrously into the sink – for some time – before turning to me. Whatever was in the pot was now a glossy brown.

'Rika, I made dinner. Will you join?'

I quietly declined and walked up the stairs. There was no one on the bridge.

[A-4] *Breakfast Blueberries (Frozen) 3 count*
[A-7] *Strawberry Waffles (Industrial Size)*
 2 count

The dolly creaked as the four wheels swerved, and I threw all my strength into halting it. My breath was short and rose in white puffs. I regrouped, plotted my path, and leaned in cautiously. As the dolly began to move forward in a straight line, I relaxed my shoulders and took the picking list from under my arm and placed it back in my pocket. I blinked a few times and noticed my eyeballs were ice cold.

As I steered towards a different shelf, Ikeda called my name. 'Can I talk to you later? We need someone to cover a few extra shifts this month.'

Yes. My reply froze in mid-air and crashed to the floor. But nobody here seemed to care about not hearing me. Not in a freezer warehouse that was twenty below. Employees lumbered around in thermal jackets

adorned with the company logo, looking like polar bear ghosts, while a peculiar yellow reflection shone on the dull silver door. A sleeve came undone, and I refolded it. I had on an extra pair of sleeves over the jacket. Inside the giant freezer, I resumed my search for the next item.

[C-1] *Kurobuta Pork Dumplings (Lunch Box Size)*

The first time I noticed it was in elementary school. We were learning about perpendicular and parallel lines in maths. 'Now, class, take a look at the window,' the teacher said. 'Do you see how the top and the right side of the window frame meet in the corner? That is called a perpendicular angle.'

The teacher was heavy-set and always wore a corsage pinned to her chest. One day it was a sweet pea that looked sugary and edible, and on a different day it was a rose the colour of my veins. She never donned the same corsage twice, and I wondered if she had a special room in her house to store her collection.

'Now, take a look at the top and bottom. See how both are perpendicular to the right side of the frame. They are what's called parallel. Parallel lines stretch forever and never meet.'

They never meet, I repeated to myself, feeling as though I'd accidentally overheard someone making a horrific prediction.

That was when I noticed that my hand, holding a pencil, was veiled by a long yellow sleeve. And it wasn't just my hand and arm. The yellow wrapped around my torso and continued down to my feet. Stunned, I stood up without thinking, causing my chair to fall over with a thud. The class turned to look at me – including Yuki.

'What's the matter, Rika?' the teacher asked without changing her tone, as if she were asking me how two lines were positioned. 'Do you need to use the bathroom? Do you feel sick?'

'It's not that,' I replied, staring down at my toes, which were now peeking out from beneath flapping vinyl. 'Something's wrong with my clothes.'

'What's wrong with your clothes? The little bear is adorable.' Her round face softened into a smile. I glanced down and the yellow vinyl was gone, and I was back in my plain green sweater with an embroidered patch of a dopey bear sewn right above the hem.

Flustered by the sudden disappearance, I mumbled, 'Uh, bathroom,' and scrambled out of the room. The class exploded into laughter as though somebody had flipped a switch. Maybe there really was a switch,

one that signalled when to tell a joke, or when to join the after-school gathering in the park.

I'd stepped out into the hallway, though I had no urge to pee. I scurried to the bathroom anyway, to wet my hands in the sink before returning to the classroom.

The yellow colour appeared again the next day, and every so often after that. At first it was just a flash here and there in mirrors and windows. I didn't need to look hard to see it was a raincoat. With a big hood, pockets, and a cheap-looking zipper. During clean-up time at school, I pretended to wipe down the mirror while patting my stomach area ever so discreetly. A thin membranous layer clung to my palm, and though it possessed no temperature or weight, it made a crunching sound like dry leaves. I was *wearing* something. I was wearing a ridiculous yellow raincoat over my clothes.

The coat was difficult to move around in. I tripped on the hem and fell often – on the stairs, during fire drills, in the fifty-metre dash during gym class. I stumbled so frequently that the teacher worried I might be suffering from a disease of the joints. I was taken to the hospital for testing, but the doctor only congratulated me for my high bone density and sent me home. I fell again the next day.

Because of the coat's poor ventilation, I became prone to dizziness from overheating. Lunch monitor days were particularly harsh, as I had to wear a white cafeteria coat over my regular clothes, on top of which I wore the raincoat, which was more like a sauna suit at that point. I sweated so much while serving steaming bowls of soup from the massive stockpot that the other students asked if I was okay, but remembering the episode from maths class, I told them I was fine. One advantage to wearing the coat was that I never felt cold, but if I got too close to a heater, the vinyl melted and emitted a terrible stench, which meant I couldn't join the other girls when they gathered around in winter to chat or play cards.

I'd been donning the yellow raincoat for about a year when Yuki asked, 'I'm just guessing, but are you being bullied at school?' He and I lived next door to each other but never spoke at school, exchanging words only from our respective balconies at home. 'No, I just can't really relate to the other girls,' I replied. Yuki gave a curiously grave nod as he reached over the railing to pat my cheek – gingerly, as though he were stroking discarded snakeskin. That was the last time I could recall being touched by another human being.

The raincoat soon began to appear on a near-daily basis. Amid the classroom bustle after the bell, in the

middle of a conversation on a field trip bus, during tedious meetings to assign school festival roles. No longer just a reflection, it now showed up in my direct line of vision. I could feel it on my skin, and it created a soft wall between me and the outside world. My classmates' voices sounded to me like the unpleasant rubbing of vinyl, and because it was zipped up to my chin, my throat felt constricted. My own voice grew smaller. Worried about the sweat and body odour, I kept my distance from others. I got heat rash on my back and underarms.

The coat was always present, regardless of what other clothes I was or wasn't wearing, but I acquired a few techniques to get through my day. Like speaking in short, simple sentences. If the conversation got too long or I was surrounded by too many people, I pointed to my throat and lifted the corners of my lips into a wan smile, which people interpreted in whatever way made sense to them. I still sometimes tripped on the hem, but I'd perfected the art of lifting it when ascending or descending the stairs without anybody noticing – the secret was to put both hands in my pockets and lift from inside – and whenever fallen leaves or trash got stuck to the coat, a good whack with a rattan futon beater got rid of it.

Depending on how you looked at it, life with the

raincoat could even be considered comfortable. It provided the ideal nook for me to curl up in and focus on homework, and when at university I went out with someone for two months and he climbed on top of me as soon as we were alone – like he was experiencing some kind of attack – I could get through the sex without having to touch his skin.

The raincoat grew thicker over the years, and before I knew it, it had become like a second skin. When we were in high school, Yuki got in trouble for shoplifting with his friends at a neighbourhood convenience store and posting it on social media, and he and his family moved away without telling anyone.

'Ten-minute break!' Ikeda called out. As the other employees filed out of the freezer, I pretended to organise a box of frozen prawns. 'Horauchi, it's break time. Aren't you freezing in here?' Ikeda was loud – both his voice and his presence – but he always sounded as though he were fighting off a cold.

'No.'

'What?'

'I'm okay, actually.' I raised my voice a notch, then exhaled.

I was still at university when I spotted a job listing for 'freezer warehouse worker', and since graduation I had worked in a few different freezers via a temp

agency. The job was far from easy and the raincoat did little to protect me from the cold (like the other employees, I too wore Heattech under my thermal jacket), but no one tried to talk to me inside a freezer. Most importantly, I didn't have to worry about perspiring. I rarely went outside during breaks because the surge in temperature meant I would instantly be drenched in sweat, but in this workplace, that made me a good employee. To them I was quiet, diligent, easy to manage.

Ikeda headed towards the door for his break, then turned to me.

'Would you be able to add a few more hours this month? A part-timer just quit.'

'Sure,' I replied, then remembered. 'Except Mondays.'

'You have something on Mondays?'

I pointed to my throat with a head shake, pretending I wanted to say something but couldn't. With a smile and a nod of understanding, Ikeda gave me a thumbs-up and left. The bulky door eased shut behind him and a hush fell over the building.

Being in a freezer warehouse didn't mean there were icicles and snowy surfaces everywhere. The place looked like a regular warehouse; it was just absurdly cold. I stretched my arms, hoping to loosen my

near-frozen shoulder blades, then gazed at the rows of prawns on the shelf before me.

[F-2] Quick-Freeze Ikejime Prawns

Live prawns that had been placed in ice water until frozen, their soft bodies hardened like steel.

Surrounded by frozen products, I sometimes tried to picture the last thing the creatures had seen. What were the prawns thinking as they sank into the ice water? Did they gradually lose consciousness, like the sky at dusk draining of colour? Did they ruminate on the good times they'd had in the ocean, or perhaps go down hoping for harder shells in their next life. What did the blueberries one shelf over reminisce about? The glistening morning dew on the leaves in the orchard? The evil shadows of birds that had ambushed and seized their precious friends? I kept going. And what about me? If *I* froze over, would I be given a shelf – a place where I belonged – that could hold my mind and body and everything else? I reached out my arms, waiting for frost to cover my fingertips.

The silver door opened, and the freezing paused.

'Ready for the afternoon round?' Ikeda's voice rang out as the polar bear ghosts lumbered to their

respective shelves. I pushed the dolly towards a new shelf.

[H-3] Imperfect Ningyo-Yaki Cakes (Red Bean Paste) 4 count

*

'Latin is a fusional language. Latin nouns change according to six cases, and verbs have six tenses, three moods and two voices. Adjective endings change depending on gender, number and case.'

I was ready to give up after the first lecture. It was too much. But as a first-year student, I didn't know that dropping a class was an option, and so the lectures continued.

You are looking. Indicative mood.
You should look. Subjunctive mood.
Look. Imperative mood.

I studied the inflections of a language that was no longer spoken, slowly burying myself in the tenses and rather lenient word order, learning how to carry the words one by one. In class I found my throat opening and releasing with less effort than when I spoke

my own language. I was protected, in a sense, by the difficulty. I felt shielded in the way a swirling shell safeguards the vulnerable body of a snail.

Conversing with another person, however, was a different story. Especially when the person was a gorgeous marble goddess poised on a platform.

'Eyelashes.'

Finding myself captivated by the beauty of her ivory eye-folds, my lips made an audible stain in the gallery. I stiffened. I'd just said a word I had no memory of learning, a word that was not appropriate for this setting.

'Eyelashes?' Venus's voice hardened slightly.

'I noticed you don't have . . . eyelashes.'

My eyes darted up towards the skylight, needing to escape her gaze. The invisible zipper of my raincoat inched up and squeezed my throat, the odour of sweat needling my nose. Venus scanned the room without moving her neck, then said, her expression unchanged, 'You're right, none of us do. I never noticed that before. I wonder why they decided not to carve any. Why do you think that is?'

I thought long and hard but my reply was neither witty nor correct. 'So they don't collect dust?' I stammered. 'No, can't be that.'

The goddess blinked. Eyelids she had.

'I don't know either. The sculptor probably didn't know what he was doing and just copied the other sculptors. We have no facial hair at all. Perhaps we're not permitted to have hair except on our heads.'

She chortled. Her laugh sounded like raindrops. I breathed a sigh of relief and felt the zipper gently descend.

*

On my second visit, the goddess stood where she had before, her lush body curved to perfection, a soft smile cascading from her face.

'Let's share a little more about ourselves today,' she suggested. 'The last time you were here, you looked as though you might faint if you spoke more than ten words.' Her voice was clear and articulate, even amid the multilingual chattering of the other goddesses. 'Okay, I'll start.'

Venus was born in ancient Rome. She was carved by a Roman sculptor, though most of his fellow artisans at the atelier were Greek. The sculptor, enamoured by the Greek artworks brought back by Roman troops as war trophies, abandoned the sculptures he'd been making of aristocrats of the same era to recreate

the more classical works instead. While he was taken by the beauty of the art that had arrived from the east, however, he was indifferent to the languages of those countries.

'If only I spoke ancient Greek. Then I could communicate with the people here. Like that girl over there. She only speaks Greek,' Venus whispered, eyeing the sculpture carrying a pitcher of water. The other goddess had long flowing hair and wore a gentle archaic smile, her posture the picture of symmetry.

According to Venus, many of the sculptures who had been exhibited in overseas museums for extended periods of time, including her, spoke some English, but their vocabulary tended to be limited to greetings and a few short phrases. Almost everyone, without exception, knew how to explain where the nearest bathrooms were located, which they shared with discretion whenever they noticed a pale visitor scanning the room urgently.

'I heard the Japanese sculptures don't speak English. Especially the Buddha statues,' she said with a frown. 'Okay, your turn. How is it that you speak Latin?'

'I happened to take a Latin course my first year of university.'

After listening to the sound of her sweet, sing-song

voice, my Latin came out in fits and starts, like someone trying to eat a sour, unripe peach.

'But that can't be the only reason. Many people can read and write Latin, I'm sure, but I haven't met anyone who speaks it as well as you. Aside from Hashibami.'

'My pronunciation could use work.'

'There's no right or wrong. Since nobody speaks it anymore! Just speak freely,' Venus laughed. 'Did you have a heritage speaker to practise with?'

'I took a few more courses my second year and after, in my spare time. The class credits didn't hurt.'

Venus trained her gaze on me, her eyelash-free eyes locked on mine.

'Hora, tell me the truth. Is someone in your family a priest in the Vatican?' she joked. I caved and started to tell her – or stammer awkwardly – about my short-term study abroad in Finland.

I'd signed up to study abroad on a whim, and in Finland, my roommate was a reserved girl who always had the radio on. One day, she was listening to a Latin news segment that was airing, for some reason, on Finnish national radio. I was having trouble keeping up with the rambunctious exchange-student crowd at the time, and when I heard the words flow out of

her old radio, I felt comforted and stopped to listen. Words I never thought I would hear in audio form, let alone on public airwaves.

'Life is short,' my roommate started.

'And art long,' I finished.

From then on, she and I started communicating in Latin. It wasn't so much to deepen our friendship as it was about the training. Like boxing. She adjusted my form, checked my jabs, made me spar with her daily. Before we started, I couldn't keep my long and short vowels straight, but with her as my trainer, my Latin improved significantly. The sudden emergence of Latin lessons in my life turned out to be a great excuse for bowing out of weekend excursions and other exchange-student events. While the students oohed and aahed at the Moomin Museum and danced the night away in clubs, I was in my room trying to gain proficiency in an ancient language that nobody spoke, although it had left its mark on languages and philosophies the world over.

As I told my story, Venus laughed, sounding once again like scattered raindrops. She offered me some tea.

'I hope you like it. I don't know tea very well and had Hashibami select it.'

'It's delicious, really.' I meant it.

Hashibami had placed a teapot and cup with a golden vine pattern onto the uncreased tablecloth and whispered, 'We're not really allowed to have food and drinks in here . . .' The tea had a deep red colouring but was light in flavour, with a touch of honey in its aroma. The cup that had been set down in front of Venus had stopped steaming long ago, its contents untouched.

Pretending to gaze at my cup, I stole a glance at the goddess. Under the Art Deco-style lighting fixture decorated with dolphins, I listened as she described the museums she had seen around the world; she reminded me of a sought-after movie star giving interviews to the press. Countless museum pedestals had longed to be home to her beauty. My body stiffened again.

'Hora,' she whispered as my raincoat's hood came down over my eyes. Snails were such cowards, I thought suddenly. Much more so than slugs, who decided they could do without shells.

'How lovely it must be,' I said. 'Being chosen all the time.'

'But I don't get to do the choosing. Ever.'

Her smile never wavered, but her voice sounded terribly dry. It had stopped raining outside. I thought

about my old roommate, and how I'd come back to Japan without getting her email address.

*

'Are you and the granny lesbians? Even though she's like, super old?' The question had been thrust upon me while I was checking my mailbox, shortly after I moved into the apartment. I had just come out of Seriko's room after she'd called my landline to say, 'The TV won't talk.' (The volume on her hearing aid was turned to zero.) I'd peered into my mailbox to find it stuffed with pizza delivery flyers – whoever had been distributing them must have thrown in the towel – and I was trying to yank them out. The inquiring voice belonged to the boy next door. I'd seen him sitting in front of his door a few times. He was my neighbour to the left; I'd never met my neighbour on the right, though I knew he showered at dawn while yelping like a sea lion.

I noticed the boy's top front teeth were missing. I thought about how to reply. *She and I both exist on islands*, I might say. *Separate islands, where no planes or boats ever visit.*

But the words dropped to the ground, unable to surmount the vinyl material. I made my usual troubled

face and pointed to my throat. 'You can't talk? Are you sick?' The boy looked concerned.

I buried my face in my hood and pushed the pizza flyers towards him before scurrying up the stairs, tripping on my hem several times. That night, the aroma of margherita and teriyaki mayonnaise pizza wafted through the apartment building.

*

I followed Hashibami in the direction of the exit. I wasn't permitted to walk through the corridors without him to accompany me, perhaps as a security measure. I repeated Venus's words in my head, recalling the dry echo of her voice, that frosty smile. I wondered if she didn't sound a tiny bit arrogant, complaining about being in such high demand.

Hashibami turned. We'd arrived at the grand staircase that led down to the ground floor, which was draped in a red-black carpet that made it look like a magnificent tongue.

'Do the days feel short to you?'

He sounded like an interviewer on the street. *Do you feel the economy is improving?*

'Yes.'

'A year?'

'A flash.'

'What about a lifetime? Life expectancy is eighty or ninety years in this country, but do you wish you could live longer?'

I traced the railing with my fingertips and gave his question some thought. I couldn't figure out what the curator was after, so I lined up a few words that I had to hand.

'I don't need to live that long.'

'Even if you could stay young and beautiful forever?' Hashibami squinted.

When I'd met him the previous week for the first time, I couldn't take my eyes off his symmetrical features, but upon closer observation I noticed his skin was awfully pale. As if he'd run to hide in the dark from something but had fallen asleep and hadn't seen the sun in years.

'Yes. I can't think of anything I'd do with all that time. And I'm not beautiful,' I added, scratching my elbow under my raincoat. My skin had broken out in a heat rash.

As we descended the stairs, I noticed some type of leaf or fossil on the stone railing. When I was a child, my uncle once took my cousins and me on a camping trip where we went fossil hunting. The person at the campsite reception desk had told us we might find

ammonites, which made my cousins dig fervently, but the riverbank designated as a quarry was massive, and every other rock looked like it could be a fossil until I started to feel that *none* of them were. I stopped searching in earnest and only pretended to dig. If I were an ammonite that had existed peacefully for tens of thousands of years, I would be stunned to be dug up all of a sudden. And I thought, even if my cousins did excavate a few fossils, which they would take home happily that day, the rocks would soon get stashed in a closet along with perfect-attendance certificates and arts and crafts brought home at the end of each semester, their existence all but forgotten by the time the cousins grew up and left home.

I'd walked past Hashibami without realising it. He stood halfway down the staircase, pondering something as if he were checking a questionnaire for skipped answers.

He caught up to me and asked, 'You've never been in love, Ms Horauchi?'

I shook my head. There was something definitive about his tone, though he'd phrased the sentence in the form of a question.

'When I'm in love, I find myself wishing I could live forever. Either that or I wish everything would end, right here and now.'

Love. I flinched. His words hit me like sparks in a vacuum tube. I finally asked, out of politeness, 'Which do you wish for more?'

'I would say both. I wish things would stay as they are right now, but that it would continue for eternity. That's probably why I'm so fond of sculptures. I prefer sculptures over people. They never leave my side.' Hashibami smiled softly.

I averted my eyes from the shiny curator's badge on his chest and replied, vaguely, 'And their beauty.'

'Right. I love that they don't move or speak up in public.'

He resumed walking, and when he reached the exit, he flung open the door. The city in April greeted me as it always did, simple and uncomplicated, full of life and vigour.

'Will I see you at the same time next week?'

'Yes.'

*

The first surprising thing about working in a freezer was that it wasn't a winter wonderland inside. The second was that pens didn't work (ballpoint pens dried up, and marker ink didn't stick to surfaces), and third, that employees took frequent breaks. Rest was

encouraged, and at my current warehouse we were given a break in the morning and two more in the afternoon, in addition to our lunch hour.

'Time for lunch!'

As soon as Ikeda's nasal voice echoed throughout the warehouse, we dropped what we were doing and headed to the breakroom, dangling convenience store bags and bento boxes wrapped in cloth. In addition to the usual 'Good work', it was customary for us to say in greeting, 'It's warm out here.' When you work in a freezer, the outdoors, even in February, will feel balmy. We all became a size or two smaller without our thermal jackets, and we enunciated each syllable as if defrosting our words.

But while we exchanged greetings, none of us were adept at small talk, nor did we have anything in common. We sat in every other seat and ate our lunches in silence, after which some people put their heads down and napped, while others stared at their phones. The staff consisted mainly of young men, and though fewer in number, women much older than me. The men came and went, but the women tended to be long-time employees. They often had reddish skin and were built like fighting dogs.

There was no bell or call to signal the end of lunch,

but when the time came, we stood from our chairs one by one and headed back to the warehouse, as if we couldn't wait to be frozen again.

Later, as I was packing up for the day, someone tapped my shoulder. 'Are you all set, Ms Horauchi?'

I turned around to see Ikeda. Employees were given a twenty per cent discount on warehouse products, which meant my home meals often consisted of items purchased there. Often? Always. Some people might have considered my eating habits unhealthy, but frozen vegetables required no washing, making them more sanitary than fresh vegetables, and they were cut into perfectly equal sizes. I cooked the frozen meat without defrosting it and hadn't touched raw meat in years. The ready-made dishes used no additives, making them healthier than a lot of homemade food. At least, more nutritious than the plates Seriko placed in front of me.

I filled out an employee discount form and went home, popped a frozen pizza in the toaster oven, made soup using the frozen vegetable mix and frozen sausages, and then went to bed. I wasn't sure when it had started, but I dreamed only in still images.

*

Certain words were missing from Seriko's speech, though what went missing often changed. When I'd first started living in the apartment I was still at university, and she once noticed a book of poetry I'd taken out from the library for an assignment.

'What is your book?'

'It's a poetry collection.' I showed her the cover. If I remember correctly, she'd called me over that day to look for her arthritis medicine. I'd searched for ten minutes and spotted it in the shoe cupboard. But Seriko was busy gazing at the book.

'Poetry.'

'Yes, poetry.'

'Sorry to touch your important book poetry. Book *of* poetry.'

Seriko often corrected herself, apologizing just as frequently. *I don't always need it. All the words. People got mad at me long time ago for talking too much. I talk too much about nothing, they said.*

I'd asked her a few times when 'long time ago' was, but she always began the story with how she had been born with birth asphyxia – the umbilical cord wrapped tightly around her neck – and then told me about the old lady with the enormous behind who lived next door, and how, when she was five, she'd slapped her

younger brother's forehead with a ruler because her parents coddled him, and how they had locked her in the shed. That was the climactic moment in her story, and she always ended there. Her life between age five and the present was still shrouded in darkness. I had no idea how old she was. Whenever I saw Seriko, she was either watching TV or doing patchwork in her onion-scented apartment. The patchwork evolved daily into a massive heap of cloth, the use of which was unclear.

I passed her the book of poetry, which she flipped through gingerly, sighing, before returning it to me. The title of the collection was *Apples and Steam*.

'Person who wrote these must be very smart and important.'

'I'm sure that's why it became a book.'

'Your words becoming book. I could never do. Nobody would read it. I can barely read myself.' Seriko covered her face with both hands. Her short hair was white but her skin was quite luminous, and her gestures made her look both extremely old and childlike.

'But . . .' I took a deep breath and continued. 'Maybe . . . this person wrote poems because nobody listened to them in real life.'

Seriko widened her eyes, her brows lifting.

It wasn't until the next morning that I realised

I'd left the book in her apartment, not until I heard a faint voice reciting from below, 'Apples don't hate steam.'

Reading aloud each morning soon became Seriko's daily routine. Who knew where she got her material – everything from novels to magazine horoscopes to official government reports. It was a morning ritual she apparently wished to practise in secret, as she stopped reading as soon as she heard me come down the stairs. It soon became *my* daily routine to lock my front door loudly and stamp my feet a few times before descending.

*

On Saturday morning, I woke up later than usual and reheated a pot of curry I'd made the night before. For the first weekend in some time, I didn't have to work, not even a short shift, and I planned to eat curry for two consecutive days and do little else. The curry contained frozen seafood mix purchased with my employee discount. I placed the pot filled with equal-sized pieces of shrimp and squid onto the stove, then opened up a YouTube livestream on my computer.

I enjoyed watching live videos from all over the world: Italian piazzas, the Namib Desert, the tourist

centre in Bangkok. I had no desire to visit any of the places. Not even a little. But I was comforted in the knowledge that these locales would never merge. At a terracotta-hued piazza in Florence, tourists took selfie after selfie with gelatos in hand. In the desert, the watering hole where animals convened was sometimes overrun by oryxes with their too-long horns, and in Thailand, irate visitors hurled demands at tourist centre personnel behind the counters while the staff retorted just as indignantly. I watched without knowledge of the humidity or smells around them, or how brightly their eyes shone. The sun simply rose and fell in every city.

In the mood for a livestream nearer to me, I selected a random region in Japan. It was a perfect Saturday in April. Next to a three-lane road where cars zipped merrily by was a pavement lined with trees. Apparently colder than where I was, people wore heavy coats but had a bounce in their step. The trees swayed in cheerful waves, and even the home improvement retailers I'd never heard of and the sushi chain restaurants seemed to sparkle onscreen. I imagined the bulbs in the gardening section dreaming of the moment they would sprout, and the shine on the seared salmon as it made its way around the conveyor belt in the manner of a diligent security guard patrolling the premises.

As the aroma of curry filled the room, I watched people walk in and out of frame. There was a family pushing a pram; a man with a large briefcase. A chihuahua in a fluffy outfit was being scooped up by its owner, while an unclothed Shiba Inu watched from his perch below. *Don't be jealous*, I relayed silently to the Shiba Inu. *The little chihuahua's going to sneeze so hard it loses its too-large eyeballs, just you wait.* The dog started walking as though it understood me. *Atta boy.*

Behind the Shiba Inu, a couple of slow walkers ambled down the street. The woman tipped forward every few strides as the man yapped away, his arm wrapped firmly around her waist as if to keep her in step with him. This infuriated me. In my mind, the woman was a naturally fast walker whose nickname in high school had been F1, like the races. Right now they were on their way to see a movie, and during the best scene, the guy would undoubtedly ask why the protagonist was crying, which was going to piss her off so much that she'd dump him at the train station on their way home. I felt better knowing that.

But the most striking figure walking down the street had to be the girl carrying a black bag with a fold in the middle. It held a pair of ice skates. I knew, because there was a skating rink down the street. The

bag was slung over her shoulder as she strode with confidence, her muscular legs making her school skirt flutter – I could see she wore biker shorts underneath. I squinted at her sunny presence; she was bursting with life. She was about to let loose on the ice, gliding at a speed too fast for any of her classmates, teachers or parents to catch her, before she soared into the air, spinning who knows how many times. I couldn't help but applaud. The rink would fill with bouquets tossed from the audience.

And then there was her hair. I peered at the screen for a closer look. Her long black hair blew in the breeze, every so often revealing a streak of pink so vivid that I had to catch my breath. It was like she was concealing a secret springtime bomb.

How does one do that? I thought, patting my own hair. My hair was rough and brittle, not dissimilar from a taxidermied beaver I saw at the science museum when I was a girl. My hair had never been dyed or permed, and I had it cut by my aunt, who I saw once a year on New Year's Eve. The walls of her room were the colour of mock strawberries and plastered with photos of dead celebrities. Her favourites were Princess Diana and Sai Baba.

'What do you want?' she'd ask.

'Same as always,' I'd reply.

'Tell me if you ever want to dye it,' she'd say. 'I'll use herbs from the backyard. No damage to your hair. I don't want to hurt or be hurt by anyone any more.' She'd sniffle as she cut my hair, which always ended up slightly uneven.

Realising my room was now permeated with the smell of curry, I stood to turn off the stove. I needed to defrost some white rice.

At that precise moment, the girl onscreen turned and walked towards the camera. Though I couldn't make out her expression, I could tell she was looking into the camera – straight at me. And then she waved with her entire arm. Three times.

I hurried to close the page. My heart raced, the blood rushing all the way to my fingers and toes. It was as if she'd knocked on a door I thought only I could see. What shocked me more was that I had waved *back*. Once. I hugged my arms close to my chest, as if to prevent any more involuntary muscle movement.

I was almost done defrosting my rice when I realised someone was knocking on my door. My actual front door, the one made of steel. The knocking wasn't loud, but it was persistent. Should I answer? My curry was steaming, and the rice would finish heating in twenty seconds. But the freeing sensation I'd felt

earlier, as if a breeze had blown through my raincoat, carried my two legs towards the door.

'Curry.'

It was the boy from next door, the one who'd asked me the question by the mailboxes. He held out a plastic plate. His orange sweatshirt looked faded.

I took his plate and wordlessly scooped rice and curry onto it, then handed it back to him. His hands were shaking, enough so that even I could tell. 'Thanks,' he said and looked at me. Startled by his long dark eyelashes, I closed the door in a hurry and sat on the floor to collect myself before heading to the freezer to get more rice.

Aside from Seriko and religious door-knockers, he was the first person to ever visit my apartment.

*

'Hora, how are you at entertaining yourself?' Venus asked out of nowhere.

The afternoon had a light green hue. The drizzle had dampened the small hairs on my face, even under my umbrella. The rain shrouded the jasmine and rose petals in front of the houses, now that magnolia season was over. The moistened plants cast a pale

shadow over the museum, dyeing it a melancholy hue that resembled Venus's marble thigh.

'Entertaining myself?'

'Yes. I am bored out of my mind standing here every day. I need a way to amuse myself.'

Her words travelled through the air in a gentle arc before landing softly in my head. *Entertaining myself.* It was true that I preferred to be alone over playing the let's-find-the-remote-control-or-patient-registration-card game with Seriko. But what tips could I possibly share with Venus? All I had to offer were trivial, meaningless games of the imagination. Nobody could take them away from me, but they were also of zero value to others. The yellow vinyl agreed, swaying back and forth.

But then I remembered that vivid pink streak and felt a surge of energy. I glanced into the hallway and whispered, 'See those people over there?'

'Where? Oh, those two gentlemen?'

The gallery door was wide open – Hashibami must have forgotten to close it – and two men were walking down the hallway. An older man, wearing what appeared to be a bishop's robe, walked a few steps ahead of a man who had donned a jacket and a bored expression.

'Oh, that's not good. That man in the robe doesn't know the other guy's true identity. The guy's a hitman.'

'A hitman?' Venus's voice grew a slight edge, making my raincoat sway again. I grabbed the hem with a steady hand.

'See how close he's walking to the bishop, all sidled up next to him? I think that's a knife he's fiddling with in his pocket.' I was surprised by how the words flowed out of my mouth. At just that moment, the man moved his hand inside his pocket. Perhaps he was searching for the gallery key, as I soon heard a jangling sound. Venus raised her eyebrows. Or what would be eyebrows, if she had them.

'You're right. Look at the bishop moseying around the museum, not suspecting a thing!'

'Don't worry, the guy won't kill him just yet. He's a smooth operator. Look at him, pretending to yawn.'

In our story, the employee giving a tour of the museum was a hitman, and the visitor his target. The hitman was extremely skilled, stretching and acting bored while keeping himself in his target's blind spot, except while opening doors. Every so often he pretended to jot down notes, twirling the pen in his hand so the sharp end was pointing at the bishop's neck artery. When the pen tip stretched towards the

bishop, we held our breath giddily, and when the bishop turned his head prematurely, we sighed in disappointment.

Since we couldn't speak out loud, I stood and whispered in Venus's ear. From the side, her ear was lovely but slightly misshapen, reminding me of a wood ear mushroom that had softened in water. As the bishop approached the door of the gallery, Venus and I exchanged glances, and as he peered into the room with a curious expression, her lips emitted a few short breaths that grazed my neck. When the pair left and headed down to the ground floor, she let out a sigh of relief. At least, she seemed to.

'Hora, dear, is this kind of thing always going through your mind?' Her voice was huskier than usual, perhaps from laughing too hard.

'No, it's just a game I thought up a few minutes ago.'

'Well, I'm going to start observing the visitors too. I'm tired of being stared at all the time.'

Venus and I continued to chat, admiring the man with the gift for killing. There we were in the small octagonal room, exchanging secrets in a language that now survived in text form only. Midway through our conversation, I pulled away, suddenly nervous about my sweat. When her expression clouded over, I tried to explain myself. 'Oh, it's just the smell . . .'

'Honey, my nose might be aesthetically pleasing, but it's got a defective mucous membrane. I have no sense of smell. If I were in the wild, I'd be dead by now.' She smiled and continued, 'But back to the game. Now that I think about it, I'm not sure I can play it on my own, when you're not here.'

Her smile, at once troubled and affectionate, slipped through the zipper of my raincoat and eased its way to an unfamiliar groove in my heart. I had never noticed the groove before; it was tiny but intricate in structure, and her words, both gentle and domineering, became snarled in its creases. Intoxicated by the pleasurable pain, I had inched closer to her when I heard, 'Thank you for coming today, Horauchi-san.' I hadn't noticed Hashibami standing there. I yelped, surprising myself a second time with the volume of my voice. Venus let out a low chuckle.

I was heading out of the gallery with Hashibami when the bishop and hitman appeared before us. I turned to look at Venus – I couldn't help it. She winked. What I felt in that moment felt more fleeting than magic, more vivid than a spell.

After I left the museum, I roamed around the neighbourhood for a while, not wanting to ruin the moment by getting on the bus. As I retraced her voice, her side profile, and her words, the late afternoon air melted into

tenderness, transforming a trash dump with illegally discarded chairs into a frameless landscape painting. The rain had let up, leaving the asphalt shimmering like diamonds. Spring had just begun. The city still glowed with daylight, the violet sky so translucent that it made my chest ache, and I felt as though my two legs could take me anywhere. I kept walking.

*

'Welcome home. You were at school?'

Seriko was sweeping out front with a bamboo broom. I had reached the apartment building without any memory as to how I'd got there. The ratty broom bristles seemed to be effective only in flattening the fallen rose petals on the ground, but the heap of flowers resembled a kaleidoscopic pattern, mesmerising me for a moment.

'No, my part-time job.'

'Oh yes, speaking Russian.'

'Latin.'

I turned the dial on my mailbox. I never received anything important, but I checked the mail daily for security purposes.

'Rika,' she said as I pulled out a pizza flyer. It was from the same pizza chain that had stuffed my

mailbox full of coupons a while back. There was only one today. Seriko peered into my eyes. In the sun, the thin translucent hairs on her skin were tinted gold, making her resemble a sort of heavenly creature. 'Rika looks pretty today,' she giggled softly.

I raced up the stairs to my apartment, nearly tripping on my hem. Without flipping on the light, I ran to my bathroom mirror where I saw, amid the used towels and scattered toiletries, my skin faintly radiating, my lips and cheeks coloured like an unrecognisable organism. I caressed my eyelids, my eyebrows, my hair. Touched the hood of my raincoat. The yellow synthetic fabric made a weary sound as it slipped to the floor.

Listening to somebody repeatedly press the broken doorbell next door, I mused timidly on the sweet afternoon.

*

I found Venus in the same place the following week, her body still curved in the magnificent S-shape. She widened her eyes as soon as she spotted me. 'Hora, I love it. Come over here so I can see.'

I shyly raised the hair off my neck. I'd got green peekaboo highlights.

'Oh, I envy you,' Venus murmured. 'I've had the same hairstyle forever. If it were up to me, I would get bangs. Then I could hide the fact that I don't have eyebrows.' Her wavy hair was braided tightly and swept back. In a classical hairstyle, if you will.

'I think you would look great with bangs,' I said, making a frame around her face with my fingers. And I believed it. If you could undo marble-plastered hair, that is.

'Then again, if it were up to me, I think I'd put on some clothes first. Before the bangs. But I do love your hair,' she repeated. Her words shot through my body like a dentist's anaesthetic and I felt my cheeks flush. I showed her the slight flip in the back before sitting down to the tea Hashibami had prepared. I was terribly thirsty. Had been since yesterday.

I'd made an appointment at the hair salon based entirely on online reviews, carefully avoiding comments such as 'The stylist was fun and chatty and catered to my every need' and 'A chic, modern space with floor-to-ceiling windows'. Once the reservation was booked, I prepared myself for the visit by going through the motions in my head. Open salon door. Give receptionist name and appointment time. Tell stylist desired hairstyle. Get hair shampooed. Do not laugh because it tickles. Hold normal conversation

while hair is cut and styled. Say something positive when shown final look. Pay money and leave salon. With the exception of the final step, the second half posed quite a challenge. I made a mental list of conversation topics: the weather, the rise in inflation rates, pets I'd like to one day own.

But I was tested from the word go. I followed the directions on Google Maps, only to arrive at a funeral home with a purple sign and a small flower bed of chrysanthemums that bloomed riotously. An ad on the glass door read:

> *Ask us about Buddhist altars,*
> *altar equipment and memorial services.*
>
> **Also available for Shinto and*
> *Christian memorial services.*

I double-checked my location on my phone.

'Do you have an appointment?' a raspy voice asked.

The heavy wooden door opened and out stepped a woman in a suit, with tightly permed purple hair and a sturdy frame that made me think of a tree trunk. I had a flashback of the oak tree on my preschool playground.

'Appointment?' she repeated. Her eyelids were

painted a shiny blue, and the smell of incense floated through the air. I prayed I'd made a mistake. But the woman glanced at her page-a-day calendar and said, 'Oh, Horauchi-san?' Her tone was kind and her question direct, leaving me no choice but to nod.

The salon was small and lined with Buddhist altars of all sizes. The woman manoeuvred her brawny body as she walked briskly to the back of the store. 'Be careful, it's a little tight right there.' A display case of rosary beads was covered in a thin film of dust.

I was surprised to find a proper chair and mirror at the back of the shop. And a sink. Like an actual hair salon. The woman cleared the scattered magazines and blanket and invited me to take a seat.

'Wait just a sec while I prep. I haven't had a living customer in six months.'

As she slipped into the next room, I set my backpack down and took a seat on the cold leather chair. I looked closely at the mirror and saw that it was part of a Buddhist altar. The mirror was embedded into a black wooden cabinet with phoenix and pine tree carvings, but instead of a Buddha statue and offerings in the centre, there I was, accompanied by a flash of yellow. My raincoat was being stubborn today. The hood came down over my head and the zipper constricted my throat.

'Here you go, have some tea and flip through this while you wait.' The woman handed me a cup of green tea and a hairstyle catalogue, then vanished again. I surveyed the room. I didn't need to strain my eyes to see that I really was in a funeral parlour. I picked up the catalogue, its coarse pages faded a bluish-white hue and filled with beaming models whose hairdos were straight out of a music programme from the eighties.

I attempted to rise from my seat. What was I thinking, coming to a salon to try a new hairstyle? But then something odd happened. I felt a dull pain, and the mirror and catalogue vanished from sight. I realised from the cold sensation on my cheek that I had fallen. I'd tripped on my raincoat.

The woman returned, out of breath. 'What are you doing?'

'I, uh, slipped and fell.' I knew I made no sense, but she didn't seem to care, as she quickly gathered me by the shoulders and helped me to my feet. Her thick fingers were warm.

'Goodness, be careful. What if you get hurt? But it was my fault too. Making you wait like this.'

The woman covered my body gently with a smock and introduced herself as Onaga.

'Everyone calls me Mrs Onaga. I was a hairstylist many moons ago, but now I mainly do hair and

make-up on the deceased. On days when there are no funerals scheduled and it's a good day on the calendar, I cut living people's hair. Earn a little pocket money. Okay, here I go.'

Mrs Onaga slipped the hood of my raincoat off. So easily. She combed and examined my strands, murmuring, 'You have nice, thick hair. But you haven't cut it in some time. And your scalp is rock hard, feels practically frozen. What would you like to do today?'

'Same as usual,' I said out of habit.

'Same as usual? It's your first time,' Mrs Onaga said, amused. 'People switch salons when they need a change in their lives. I'll make some suggestions, but you think about what you want. You can do that, right? Since you're still alive.'

As she ran a comb through my hair, I straightened my neck and felt the zipper loosen slightly. In a rare moment of liberation, I took a deep breath and blurted out, 'Is it hard to dye just the underneath?'

*

'You really went for it, didn't you? And the length. I didn't expect this from you! You seem like the play-it-safe type,' Venus teased, which tickled me. I covered my neck with both hands. My aunt's

year-end haircuts were always shoulder-length, which meant my neck had never known the playfulness of the afternoon spring breeze, or the chilly punishment of the night air.

Once I'd filled Venus in on the hair salon outing, I extracted a portable speaker, which I'd borrowed from Seriko. It was an old thing that had been found behind her dusty treadmill, with surprisingly advanced features including high-resolution audio and smartphone connectivity. As the other goddesses paused their chatting, I pressed play. Following a hesitant pause, piano keys began to roll out a gentle melody.

I had downloaded a compilation album of piano pieces. Colourful notes danced and twinkled in the white octagonal space as the unseen keys skipped along. The music laughed and sobbed theatrically, and the right-hand staccato eased as if to nod off to sleep, before the left hand brought the melody back to life with a rhythmical arpeggio.

'Hora, who is this musician?' Venus whispered during the third song.

I rose from my chair so as not to disturb the other goddesses and inched close to her ear. Bluish marble patterns rose on her skin like veins.

'Schumann. A German composer from the nineteenth century. But I'm no expert myself.'

'He's pretty contemporary, isn't he?'

'Not your taste?' I asked, my eyes glued to her veins.

'On no, it's elegant and romantic. I adore it. We rarely get to listen to music in this room. Aside from "Auld Lang Syne", which they play every day at closing time.'

Seeing her white eyes narrow slightly, I was reminded of my groove, that tingling sensation. Venus let out the occasional sigh as we listened. Standing so close to her magnificent archaic body, I felt as if I might lose sight of who I was.

It was Mrs Onaga who had taught me that not every moment with another person had to be filled with words. Once she was done washing my hair and was ready to start cutting, she had turned on some folk music. Passionate sitar sounds had pealed through the expressionless Buddha statues.

'I'm going to shut up for a sec, hope you don't mind,' she'd said. 'Sit still if you don't want me to nick your ear.'

Hashibami walked into the gallery as the album was winding down. He turned off the speaker as the last of the notes reverberated through the room.

I'll be back next week, I messaged silently to Venus, whose eyes were wide with uncertainty.

I'll be waiting, she mouthed back.

I left the museum and wandered around the city again. When I caught sight of my reflection in the window of the dry cleaner's, I could see my hair shining and caught a glimpse of green in the late afternoon sun.

*

I'd just assumed they had been sucked into an abyss somewhere.

Back when I was in school, they always vanished after the long holiday week in May. The overcrowded campus fell silent as the unfortunate souls were swallowed up by who knows what, abandoning the professors who pressed on with their monotonous lectures as if trying to hypnotise themselves, the school cafeteria where part-time cashiers who'd started in April had finally got the hang of the cash registers, the courtyard through which the most agreeable breeze of the year whispered; they were gone for much of the beautiful weather. It was as though they'd been transported to a distorted space-time on a blueprint made by a mediocre architecture student. Either that or they had simply remembered they had other commitments to

attend to – whether by choice or obligation. And this spring, I too found myself preoccupied.

On closed days, the museum stood quietly as if forgotten by the world. Whenever Hashibami opened the door to let me in, I was met with a cool humidity, a familiar and comforting darkness. I never encountered any other employees, the environment remaining unchanged from week to week. 'You're like the manager of this place,' I told him.

'You're right,' he smiled. 'It's my job to make sure that everything here stays the same.'

I stepped in through the back door and followed him down the dark corridor and up the grand staircase. With every step, the world took on a brand-new colour, and I felt as though I could forgive myself for all past mistakes. When Hashibami finally turned the gallery key and the *click* I'd longed to hear echoed through the hall, I softly resumed my breathing.

Venus always welcomed me with that elegant smile of hers. Over the course of my visits, I'd got into the habit of pulling up my chair next to her so we could flip through photography books together. I first thought of showing her a livestream video but the museum had no wi-fi, and of the few books I'd brought previously, she'd taken a liking to the

photography. She appreciated the photos of world heritage sites and must-see views – her tastes were surprisingly mainstream. Together we travelled the world from our well-lit gallery: soaking in the limestone hot springs of Turkey, making small talk with the Buddha statues of Borobudur, marvelling from the observatory on Hawaii. Through the photos we could travel anywhere, though Venus wanted to avoid Europe. 'It would be awkward running into other Venus statues,' she remarked.

Admiring the Micronesian islands, known for having the most magnificent rainbows in the world, she murmured, 'I wonder if there will ever come a time when I can go to these places. Perhaps when humans can swim in the desert, or ride camels on Jupiter.'

I gave a vague laugh and flipped the page, exclaiming loudly over a waterfall in Venezuela. Venus hadn't set foot outside of a room where the temperature, humidity and lighting were meticulously controlled, not since she became a museum exhibition.

When we grew tired of the photography books, Venus sometimes talked about her life before the museum. The man who sculpted her had kept her by his side for some time, calling her his muse. 'Even though there are other goddesses named Muse,' she

said, rolling her eyes. But in his later years, the sculptor found himself in debt and had to sell her off to a nobleman living on the outskirts of Rome.

'My feelings were a little hurt, of course,' Venus started. 'But the home I was sent to was so extravagant, I was never bored. There were numerous servants in the house, and the mosaic paintings in the dining hall? Breathtaking. People came over for dinner every night, and they would gorge on feasts of peacock brains and snails fattened with milk, which they ate lying down, and then they would throw it all up! All the while, comedians and gladiators would take turns entertaining them.'

Venus often hummed the harp tunes that the servants had played in the house, along with standard waltz numbers heard while living in a French aristocrat's home, and the mazurka that she had heard every night when she was stolen and stashed, for some strange reason, in the barn of a Polish farmer.

'I wonder why I only remember dance music. It's not like I can dance.'

'I'm a terrible dancer too. If I'd been born a dancer, I might have never learned Latin.'

Venus smiled. 'Well, you, darling, are a gift from above.'

Like my former classmates who had disappeared into thin air, I too now existed in a distorted space-time. These afternoons in the empty gallery felt like a safely guarded paradise, protected by a dying language. The room brimmed with warmth and intimacy, the steam from the honey-scented tea moistening my cheeks. I felt that nothing sad – or lonely – could ever happen again. I purchased something called 'hair oil' to treat my new cut, which somehow led to my wanting to stop slouching, so I started lifting weights to improve my posture. I also stopped jaywalking, simply because I could.

One weekend in mid-May, I visited the library to pick up a few more photography books. The library was a small room attached to the local community centre with an impressive collection of classical literature and history books. I selected a few of them along with the photography books and spent my nights reading. I read about ten people taking refuge in a church to avoid the Black Death, learned about a war that was brought on by tea, studied the immune function of the appendix. My dreams at night evolved from still images to moving pictures.

One morning, I woke to the sound of Seriko reciting a poem, skipping over key words and syllables as she always did.

Wrapped in my light summer blanket, I listened to her scratchy recitation, my head feeling as though it were soaked in sugar, milk and eggs. Trucks rumbled into a factory nearby, and I glanced at the rattling window, where the familiar streak of yellow flashed beneath the too-short drapes. But something felt different today. I strained my eyes. The colour was a paler yellow than usual. What used to be a ridiculous, blinding yellow was now the hue of pre-griddle French toast. I reached for the hem and noticed the material seemed thinner than before. Still tough, but thinner. Like the filmy membrane that wraps around a foetus and keeps it separated from the mother, no matter how intimately connected they appear to be.

... I was in love with the marble goddess.

*

The year after my short-term exchange programme in Finland, I chose Conversational Latin from the university syllabus because I liked the description: *Acquire communication skills by learning to speak, listen, read and write Latin.*

On the first day of class, however, I found I was the only student. The professor arrived a few minutes late, glanced at me in the back row, and took attendance.

'Ms Horauchi.'

'Here,' I responded from under my raincoat hood.

At that very moment, a few members of the gospel club – I assume that's who they were – passed by the lecture room door, singing. Their love for god drowned out my reply. The professor stepped down from the podium and moved closer, trying my name again from the middle of the room. And then again. And again. Until he was two seats down from me. That spot would be his podium for the rest of the year.

At first, he and I sat uncomfortably in the spacious classroom like two strangers whose boat had capsized, and who alone had washed up to a deserted island. He rambled on about grammatical points that I was already familiar with, and in the final few minutes, we mumbled a few conversation examples to each other. As soon as the bell rang, we both darted out of the room as fast as we could. The professor sometimes had a twitch in his shoulder, and I think it was after I asked him in Latin if he was okay that he stopped explaining grammar points. From that day on, we devoted our time to one thing: Latin conversation.

'How old are you?'

'I am fifty-seven.'

'Is this a pen?'

'That is not a pen. That is a dried-up cicada.'

'What are your thoughts on democracy?'

'There is no worse form of government. With the exception of all past forms of government.'

The professor had prepared the questions, but I was happy to engage. The words leaving my mouth invited the other to speak, and our words created their own mosaic pattern. My Latin had a touch of a Finnish accent, but with the professor's help, I learned the classical pronunciation. During class I forgot about my raincoat; I was actively participating in the exchange of words. The professor and I breathed life into a nearly extinct language as though we were Frankenstein.

Unfortunately, the professor and I soon found we both lacked words, especially when it came to sharing anything about ourselves. About two months in, the professor asked suddenly, in Japanese, 'I've never had a student who can speak Latin as well as you. No, forget "student". I've never met an *academic* who can speak like you. How did you learn?'

My raincoat instantly shrouded my bare skin, as though shunning me for daring to be vulnerable. 'I . . . studied abroad,' I croaked from the small opening in the hood.

The professor gave me a quizzical look and waited for me to continue, but I just pinched and stretched the hem of my coat repeatedly, hoping he would move on. When he dropped the subject and went back to speaking only Latin, I clenched the string of my hood, relieved.

It wasn't until the last day of class that the professor attempted another personal question. It was a Monday in January, and the skies were heavy with clouds that reminded me of a duvet. The course required no final reports or exams; I would be graded on my day-to-day performance. I was putting my textbooks away when I thought I heard the professor say something. Unable to catch what he'd said, I stopped and listened closely as he slowed his speech. As though Japanese were a foreign language.

'Next year is your final year of university. Will you be looking for a job after graduation?'

He stared me directly in the eyes. 'Freezer,' I mumbled, wiping my sweaty palms. I took a breath. 'I hope to work in a freezer. I work there part-time now.'

With that, I gave a quick bow and scrambled out of the room. A light snow was falling when I stepped outside, sending a shiver up my spine. I was sensitive to heat, but it didn't mean I preferred the cold.

I was surprised when the professor contacted me

later in a postcard written entirely in Latin, saying he wanted to talk to me about a part-time museum job. I raced up the apartment building stairs, holding the postcard flickering with symbols only I could decode. I still found it hard to wrap my head around the idea that a person could write down words, send them off into the world, and somehow those words would land in the hands of the person for whom they were intended. That people did this every day without thinking twice astounded me.

*

I was scouring Seriko's apartment for her prescriptions when a woman who claimed to work for the city rang her doorbell.

'Somebody I do not know,' Seriko said, shuffling towards me with a frightened look on her face. Having grown bored of searching, she'd hurried for a glimpse through the peephole as soon as the bell rang. I went to the door and saw a woman with short, smootheddown hair, the corners of her mouth turned up in a smile.

'Let's ignore, Rika. It might be new scam.'

Seriko's voice was soft but clear. Her use of the word 'scam' must have been audible through the door

because the woman remained where she was, ringing the bell a few more times. I had no choice but to crack the door open. Seriko let out a small shriek and dashed into the kitchen.

The woman, neither young nor old, had the most average height and build of anybody I'd ever met. I wondered if it was a job requirement as a city worker that she not be memorable in any way. 'I'm hoping to ask a few questions about Apartment One upstairs,' she said in a single breath.

Apartment One. The room next to mine where the boy lived with his mother, who I'd seen only a handful of times. While I thought of how to reply, the woman said, 'Excuse me just a moment,' and inserted her hand into the tiny gap in the door, pushing it open with remarkable force and sliding her body inside. She slipped out a business card and introduced herself before I could say or do anything.

'Have you ever heard a child crying?'

'No.'

'I see, I see.' The woman took a few notes without taking her eyes off of me. Her thick pen glided across the page almost as fluidly as she had slithered into the room.

'Have you ever heard any hitting or shouting?'

'No.'

'I see, I see.'

Seriko peered out from the kitchen.

'Have you noticed anything unusual? Ever talk to them?'

'Hm . . . maybe . . . curry.'

'Curry?' the woman repeated, blinking slowly. I realised then that she hadn't blinked since entering the apartment.

I held on to my raincoat sleeve and continued in a small voice, 'I once . . . gave . . . the boy . . . curry. He looked . . . um . . . very hungry.'

'You gave the child curry? Is that what you said? Curry?'

That's what I had said. I felt as though I'd committed a crime. The woman gave me a long look and took out a sheet of paper.

'If you notice anything, please call this number.'

'If I notice . . .'

'Anything. Right away. Right away, please.'

The woman retreated with her mouth still turned up at the corners.

'Child abuse is on the news all the time,' I said. 'I wonder how common it really is.'

Seriko had come out of the kitchen, holding her prescriptions. I tossed out the expired can of salmon

I'd found during my search, thinking about the neighbour boy's faded orange sweatshirt.

*

Venus was generous about most things, but one thing she forbade me to do was to see her during the museum's open hours, when she was being observed by other visitors.

I tried to fight her on that. Getting through the week without her was becoming excruciating.

'People want to look at you because you're beautiful. I don't see anything wrong with that.'

'Even when I don't recall ever signing up for a modelling agency? Try being ogled all day long. You start to feel empty inside. Like there's not an original thought in your head.'

I averted my gaze, which made Venus titter. 'Hora, honey. You're allowed. Go on and stare as much as you like.'

I couldn't keep from grinning as I sipped my half-cooled tea. I stole a glance at Venus's hair, then let my eyes travel down to her legs, which would never walk, and up to her arms – soft in appearance but hard as a rock in reality – that would never

hold me close. The hidden groove deep inside my raincoat began to pulse. It felt both damp and unquenchably parched.

The following Monday, Venus and I had sex for the first time. I couldn't believe my ears when she first suggested it. I then thought, *How?* I had already begun to feel hostility towards the museum rules. 'Despised' might be a better word for it. *Please do not touch the art.*

'Okay, take a seat,' she said as though it were the most natural thing in the world.

Her eyes locked on to mine, engulfing me completely, even without pupils. They saw everything, from my embarrassing desire to the heat-rash scars caused by excessive scratching.

I didn't even need to take off my clothes. Nor my raincoat. Her soft, alto-leaning voice sounded to me like the open sea, and I was floating alone, staring up at the wide sky. As I floated, a small wave caressed the small dip beneath my ears before moving down to the round bone at my wrists, then down to my kneecaps. The wave brought every body part into focus, stretching, expanding and melting all that it passed. Gradually I began to paddle, with increasing desperation, as though my life were on the line. As I swam in a dream-state, another wave surged over me, knowing me, pushing me deeper. I could no longer touch my toes as I bounced around

like a buoy, grasping for her naked flesh, those artistic curves that turned to stone upon contact, and together we sank. Deeper down into unknown salty waters.

I flail, but it's no use. We're sinking. The water temperature plummets, and my cells cry out from lack of oxygen. Venus continues to smile wordlessly. I can no longer think as my hands and feet grow cold and immobile. Once I reach the desolate seabed, I feel a soft current. She smiles as if to grant me permission, then invites me to follow her. And with sudden force the current carries us, back up towards our boat. She yells instructions as we glide upwards. I touch various parts of my body as dictated, and just like that, I climax. She is an experienced captain instructing me where to go and how to get there; I have simply rowed the boat. We arrive at an island with an abundance of fresh drinking water and multicoloured tropical fruit growing on trees as far as the eye can see. I wolf down the water and fruit.

Repositioning myself in the chair, I looked over at the goddess, who was wearing the same leisurely smile as always.

'... Did that count as doing it?' I asked hesitantly.

'Did that *count*? What do you mean? What is your wish, to be strangled or something? Is that what you're into?'

I shook my head. I touched the insides of my elbows; the rash scars were still there.

'I don't know,' I whispered. 'I just wondered how that was any different from me doing it alone. I wasn't able to give *you* anything – like pleasure.'

I suddenly remembered the other goddesses in the room, mortified, but they continued to chatter on, either uninterested or trying to avoid looking at us. Demeter, the goddess of harvest and agriculture, kept fluttering one eye. She was practising her winking.

Venus appeared hurt. As hurt as she could look without wiping the smile off her face.

'How is using our voices, our words, any different from physically touching each other? It gives *me* pleasure to see the sweet expression on your face.'

'It makes me happy too, of course. To feel so close to you. But I don't know, it wasn't exactly how I'd imagined it. Like we'd become . . . one.'

I gazed up at the goddess. We were separated by a line that forbade me from moving any closer.

'Become one,' Venus said, and fell silent.

I heard the voice of my corsage-wearing teacher then. *Parallel lines stretch forever, and never ever meet.* My eyes followed the parallel lines of the white gallery tiles.

Venus finally spoke, sounding apologetic. 'I'm

sorry. I can't think of any other way to do it. Everyone before you seemed satisfied. No one has ever said this to me before.'

'Please don't apologise. I'm probably asking too much of you.'

Everyone before you . . .

I heard Demeter cluck her tongue, frustrated with her progress.

Venus shook her head, or so it seemed. 'I'm not saying that. I just don't understand.'

'Understand?'

'I caress you with my words, you react, and that turns me on. Say we *could* feel each other's touch and rub our mucous membranes together. That doesn't mean we can become one, does it? There's you, and there's someone else. You come together momentarily, but what's left afterwards? You. And someone else. Two separate beings. And then you repeat the process. Am I wrong?'

I remembered then. The thing I'd done with the man I dated for two months. I'd lie in bed, drenched with sweat inside my raincoat, watching him move his hips on top of me like a crazed seal.

'Let's try to come up with another way,' Venus said.

On my way out, we held each other's gaze longer than usual when Hashibami wasn't looking. We had

just had sex. I caught a flash of the rose-coloured sky in the skylight, and in my mind, larks soared in celebration, chirping joyously.

Which was why, when my shift neared its end the following week and the goddess asked me to move closer, I couldn't help but feel hopeful. Expectant. 'Don't tell Hashibami,' she whispered. I purposely took my time standing up from my chair, trying to hide my excitement. But when I drew close, Venus said nothing. I didn't know what was happening.

'I'm sorry. What is it?' I asked finally.

'Look closely. At my toe.'

Her baby toe was stirring slightly. Like a dying caterpillar.

'I practised bending my joints last week, on a rainy day when the museum was empty. I wish I could move it more. That girl's really good at it,' Venus said, whistling in the direction of Artemis, goddess of the hunt. The hunting dog next to her waved one ear and shook its chin. I thought it looked like a cheap toy. Suddenly, I was struck by the thought that Venus might be nothing more than an empty, emotionless statue.

'It's super top-secret,' she mumbled. She appeared offended by my tepid reaction. I scrambled to express

surprise and delight, letting out a squeal, wishing I could drown out the rustling of the hood on my ears.

*

One reason I went to the museum on a Thursday afternoon was to apologise to Venus for our last encounter. I figured she wouldn't mind my showing up right before closing, after the museum had cleared of other visitors. In my head, I could see the afternoon sun streaming into the gallery. Behind the art student studying sculpting techniques, an elderly neighbourhood man would be napping quietly on a bench, and the goddesses – so rowdy on their days off – would be standing serenely atop their pedestals. 'Auld Lang Syne' would start to play over the loudspeakers and the old man would stir, rise from the bench and make his way towards the exit, while the art student would try to remain until the last possible minute. They would pass me in the hall and I would stand tall, as though I worked there, and then I would mouth *hello* to a surprised-looking Venus. When the last of the footsteps dwindled, we would burst into laughter and share a short but satisfying tryst. That was the plan.

I clocked out of my other job a little early that afternoon.

'You're looking chipper today, Horauchi-san!' Ikeda called out as I took off my thermal jacket and headed to the dressing room to change. I had a sudden impulse to quit the freezer job, and I started to say, 'If you have a minute...' but then realised it was reckless. 'See you tomorrow,' I said, and left.

During the bumpy bus ride to the museum, I couldn't erase from my mind the idea of changing jobs. Of working outside of the freezer for once. I remembered a 'Hiring' flyer posted at the bakery near the library. Baking would be difficult, considering the heat and the sweat, but could I be useful in other ways? Slicing bread for sandwiches and toast, or squirting cream into buns, for example? The dough inside my imagination rose until the bus pulled up to my stop.

When I arrived at the museum, I didn't head for the back entrance as I usually did, instead walking for the first time to the main entrance. The prefab ticket booths seemed new, their walls shiny and smooth. 'One adult,' I expressed to the pale, round-faced ticket agent as I slipped her a five-hundred-yen coin. She slid back a small square ticket and a hundred-yen coin in change, both of which were alarmingly cold and damp. I thanked her and went inside.

It was the museum I knew well, except people were present. Though not many. With even just a few visitors, however, the building felt wrapped in a thicker silence than when totally empty. Everyone strode through the halls like they were sleepwalking, avoiding meeting anybody's gaze, as if they weren't supposed to be here. They all looked like shadows from behind, the clicking of their shoes the only life in the room. I wondered how a museum with so few visitors could afford to stay open.

I decided to browse the galleries until closing time. The ground-floor exhibition, titled 'The Everyday Lives of the People of Kaizuka', provided an in-depth look at the local area and culture. Chipped earthenware artifacts said to have been excavated nearby were on display, as well as mollusc shells, fragments of deer bone, a bowl made from chestnut trees. A stratigraphic model showed different layers of rock, each lighting up when you pushed the relevant button, and I sat there for some time, mindlessly illuminating limestone and mudstone strata.

The second half of the exhibition featured clock hands. The region was home to numerous clock industry suppliers, one of which specialised in the production of hands for clocks and needles for measuring instruments; the decorative clock

hands crafted by highly skilled artisans were widely known outside of town. But as demand for clocks had declined, the company was forced to change course and rebrand itself as a manufacturer of medical needles. The clock hand artisans were let go, and now the company was attracting attention in the medical field for its use of state-of-the-art needle-manufacturing machines.

In a display case of needles used for surgical instruments, a grinning cartoon dog or bear exclaimed in a speech bubble: *How productive!* The needles were no thicker than a strand of hair. As I regarded them, I imagined using clock hands in surgery. I pictured a baby's finger being reattached with invisible thread, human nerves resembling a spider's web being sewn together, a delicate tear in the blood vessel of a beating heart or muted brain being repaired, the gentle stitching-up of half-open eyelids on an elderly person in their final days. I imagined our bodies being sewn by time.

As I came to the end of the exhibition, a rush of exhaustion and dizziness washed over me. My body grew hot as sweat broke out on my forehead and back. I tried to breathe but my tongue got in the way, tangled up like a foreign creature. *I'll go upstairs*, I thought in a daze. I just needed to see Venus.

As I crawled up the grand staircase, my eyes landed on a wooden door I'd never noticed before. The small brass symbols indicated that it was a bathroom. I headed straight for it. I would run my hands under the tap to cool myself down. Fortunately, the door was light as a feather, and I only needed to lean slightly on it. It didn't just open. The momentum sent me flying across the bathroom as I fell onto the sink. I stared into the basin, my eyes flashing, and thought about the veins in Venus's ear.

*

For a second, I thought it was dawn. The patch of sky that was visible through the small window had been washed of colour, and the air smelled of humidity. I realised it was late when I heard 'From the New World' by Dvořák over the loudspeakers. The music, nudging visitors towards the exits, must have been coming from a few speakers, as the famous English horn solo echoed from multiple directions and sounded out of sync.

I lifted my body. Pain shot from my upper to my lower back, but I was no longer gasping for breath. My hands had cooled. If anything, they were cold now that the sweat had dried. I tried to check the time on my

phone, but the blue-white glow of the screen nearly blinded me. I closed my eyes for several long seconds, waiting for the shooting pain to subside before I could step out into the hallway.

As I walked, my footsteps appeared to disappear into my own shadow. I didn't hear the soft wind, the string instruments, the lapping waves that soothed me on the museum's closed days. I saw that in the courtyard, the plants and trees were starting to blend into their surroundings, the presence of night deepening with each passing moment. I needed a glimpse of Venus, that was all. I just needed to tell her, *I'll see you next week, okay?* and carry enough hope home with me to last until Monday. Security would start making their rounds soon. Which is why I didn't expect to see what I did, unfolding beyond the carelessly flung-open door.

My first thought upon seeing the floating white object was that it was a snake – that sly creature that tried to seduce the woman in the garden. Or a monster with eight heads and eight tails that devours young girls. But there were no snakes or monsters in her world. In her myth, snakes didn't seduce women. And she wasn't just a character in a myth, anyway. She was simply *her*.

The object wasn't a snake, of course.

Hashibami was wrapped around Venus, inspecting her, the world around them melting into twilight. Even through his mask, I recognised the symmetrical brows and eyes, and the porcelain skin, which was almost as luminous as the goddesses around him. Pointing his loupe at her marble shoulder, he drew his face so close that I caught my breath, even from afar. He inched his loupe to the side, bit by bit, peering into it as though he believed that if he stared long enough, the object before him would become his. But while the hand holding the loupe deftly repeated the process, his other gloved hand lingered clumsily on her skin. The right and left sides of his body seemed desperately out of sync.

As the loupe passed the curve of her shoulder, Hashibami released the breath he'd been holding. Venus shot him an exasperated look and hissed, 'It's so hot. Stop breathing on me.'

'I can't help it,' he said in a tone that possessed a hint of intimacy.

As the gallery shadows melted into darkness, he wrapped his arms around her and continued to inspect her body. She was all that he saw. The gossipy goddesses shielded their eyes. Artemis's hunting dog let out a growl, but Hashibami frowned and clucked his tongue, making the dog quiver and pipe down.

Was this part of a curator's job? I tried to organise my thoughts. Hashibami wore a white lab coat over his usual shirt and slacks – so he could hold himself against her, perhaps. His black-rimmed loupe looked official, its role to aid in the inspection and preservation of the statues. Statue? Yes, she was a statue. She had no choice in the matter.

And in Hashibami's arms, she looked like a plain statue. Her white eyes were blank, her upturned mouth bizarre in this context – what was funny? – and her curved pose looked forced. Her marble face, hair and body were indeed beautiful. But I couldn't help feeling a disconnect now, between her visual perfection and the blunt, sometimes sly way she spoke to me. And that laugh, which sounded like raindrops.

'Aren't you done yet?' she asked when the loupe had made its way down to her hips.

'No, I'm not done. It always takes until midnight, you know that. My job is to ensure that your beauty is preserved.'

The loupe slowed again, as if taken by the curves of her hip.

'Okay then, since this is *my* job,' Venus continued. 'I expect to be paid a modelling fee. For the fifty years I've been here. Eight hours a day with no breaks, six days a week.'

'Huh? What in the world would you spend the money on?'

'What do you think would happen if all of the statues started demanding payment? If they got so angry they started blabbing away in front of visitors? You know what you're scared of? I'll tell you. Words. And solidarity.'

Hashibami raised his face. 'I can break you.'

'Go ahead. Do it. I'm done.'

A hush fell over them again. Hashibami set his loupe down and wrapped his gloved hands softly around her. It all seemed overly dramatic. Venus sighed hopelessly.

'You know I could never do that,' he said. 'To a majestic sculpture like you. Why is it so hard for you to see how much I love you? Always snapping at me like that.'

'Then *you* stand up here. See what it's like to be ogled all day long, not allowed to say a peep, like a piece of rock without a thought in your head.'

'No way.' Hashibami snickered. 'I'm sorry, this is the way things are. We have no say in the matter. Sadly for me too.'

The inspection resumed. The cloth around the hips seemed particularly complicated as Hashibami leaned in closer still, and the room was silent, aside

from his occasional exhale. Darkness had enveloped the skylight, and as night began to encroach on the gallery, the pair floated dimly, in a white blur like two entangled snakes. I wanted to tear my gaze away but couldn't.

It's nothing, I reassured myself. As a curator, Hashibami was responsible for maintaining and preserving the artworks. In his arms, Venus wore a soft smile that someone might interpret as relaxation, like during a spa treatment. This care was necessary for her to shine atop the pedestal for two thousand years. I heard her moan softly. Hashibami's loupe traced the cloth around her hip and was approaching the space between her legs. Her perfect smile distorted slightly.

I had to face my truth. I was scared. If I walked into the room now, how would they react? I didn't know for sure. Why was she letting him control her, and why was she *still* smiling? My unseen groove twitched and shrank, sending a surge of pain through me. I hugged my raincoat tight. The synthetic fabric made a dry rustling sound.

Just then, Hashibami turned his head towards the door. I held my breath. I felt myself start to sweat, and squeezed my shoulders so the odour wouldn't seep out. I took a small step back. And another. And

then I froze. If felt like forever before Hashibami turned his attention back to the loupe and asked, 'So, how's the new part-timer? It's been about two months now.'

'Hora? She's a sweet girl.'

Sweet girl. The sound formed a complicated pattern as it fell to the ground.

'Nice name you gave her, by the way. I know you took it from her last name, but Hora? As in the Hora of Spring from Botticelli's *Birth of Venus*?'

'Yes. She places the robe over the nude Venus.' Her alto tone softened. 'I don't need an Adonis. Or a Zeus, or an Ares. Or you.'

'So cruel. You have no heart.'

Venus fell deep into thought, then tossed a look at Hashibami, who was studying the delicate details of her garment.

'Would you like to make a bet with me?'

'No.' The folds around the goddess's hips looked intricate even from afar, and Hashibami wasn't about to take his eyes off them.

'If I get her to fall in love with me, will you release me from this place?'

I felt the urge to storm the room, land myself squarely in front of the two. But the hand with the loupe would not allow it. I kept my feet planted.

'What's in it for me?'

'Okay then, how about this?' the marble mouth said smoothly. 'If you get her to fall in love with *you*, I won't see her anymore. You can fire her, and I will never speak another word. As is your wish.'

I took one step, then another. Away from the gallery, towards the exit. I sped along the corridor and down the grand staircase. The security guard locking up the ground-floor exhibition saw me and nearly jumped out of his skin, but I mentioned Hashibami's name before he could say anything. He eyed me suspiciously but let me go, and I forced my way outside. I didn't want to think about anything anymore.

When I arrived back at my apartment, I heard a voice from Seriko's apartment that didn't belong to Seriko, which was strange. I opened her door expecting to find someone conning my elderly landlady out of money, but instead, there sat Seriko in front of the TV with a middle-aged woman I didn't know. They were watching a special on the wedding of a royal family member, an event that had the entire country talking.

'Poor thing. She's not a doll. She must have things to say.'

I sniffed, and Seriko turned around. 'Oh, Rika,'

she said, her voice brighter than usual. 'I have care person now. Since last week. So I don't trouble you anymore...'

The woman, the carer, introduced herself and bowed. Her face was kind, and she had smooth porcelain cheeks. The soft skin on her cheeks and neck reminded me of the ticket agent at the museum. I turned on my heel and with a trembling hand reached for the doorknob. I thought I heard Seriko mention dinner, but I ignored her.

I dragged my raincoat up the stairs, nearly tripping on the hem, and cast my gaze out at the darkened bridge. It was empty.

*

Still, I yearned for Monday to come. I decided to think of what I had seen on Thursday as a dream. I didn't arrive at the conclusion straight away, naturally. The image of the two snakes made its way into my actual dreams. Repeatedly and relentlessly, giving me night sweats. Every time my eyes jerked open from the disturbing nightmare, I wrapped myself in my raincoat until the image faded, hoping to lose consciousness and fall back asleep. *What would Venus do if she got out of the museum?* I thought. *What will*

I *do if she gets out? What if she doesn't care about me, and what she really wants is to learn English and talk to lots of different people? What if she really prefers men who swish their wine glasses before taking a sip?* My thoughts ballooned inside my raincoat.

I worked in the freezer during the day, and at night I read books on art and history, grateful that Venus was made of marble. If she'd been made of bronze, she might have been used to make a cannon during the war and ended up at the bottom of some ocean.

Then again, she might have preferred that.

I remembered a day at the gallery when she'd thrown a meaningful glance at one of the other goddesses. Hera. The wife of Zeus in Greek mythology, a jealous goddess who had persecuted many of her husband's mistresses and their children.

'She's had so much work done. A conservator told me a long time ago that she has her face touched up each time she's due for a restoration, and she looks nothing like she did in the beginning.'

'Don't you get touch-ups too?' I asked in a chiding tone.

'Oh, of course I do. Who doesn't?'

The clouds over the skylight split then, a stream of light shining onto her silky arm. I thought of the other Venus recreations around the world. The famous

goddess statues whose arms had been lost, forgotten somewhere in history.

'I've been alive for over two thousand years. What do you expect? But none of it matters anymore. My beauty, being seen. The next time a part of me needs repair, I'm going to choose to leave it alone. Isn't there a whole-body donation process for statues? I'd be so grateful if you could sign on my behalf.'

I declined, of course. Asked her to please stop talking about it. But I also thought about the next time she would need to be repaired. It could be in three years, or a hundred years. Maybe a thousand years. I hoped it would be long after my death. On the bus ride home, I searched 'marble ageing how many years', but the only sites that came up were for kitchen and bathroom renovations, and for a while after that, every ad that popped up in my feed invited me to renovate my home.

During another of my visits, Venus had brought up memory after memory as if she were a fountain spring with endless supplies of water.

'At the public banquet the day before the fight at the Colosseum...'

'Back when Poland and Lithuania were a single state...'

She never ran out of memories. There were two

thousand years' worth, after all. But when she brought up her first lover in ancient Rome, I asked her a mean question, out of spite. 'What did you dream of becoming back then?'

'Lawyer. I wanted to know more about the rights of indentured servants.'

She'd studied non-stop and memorised the Laws of the Twelve Tables, until her 'very kind' lover said something that made her give up on her dream. *I'm not trying to be mean. But you should spend your days living blissfully, here with me. The courtrooms are ruled by men who can walk.*

'Now ... hmm, maybe I'll shoot videos and post them online. My audience will be Latin-speaking statues in museums around the world, or maybe students at schools in Europe who are required to take Latin. If only I had fingers, so I could edit the videos.'

I instinctively hid my hands. I imagined Venus speaking fluent Latin, more fluidly than she spoke to me, with a marble Zeus and a bronze Apollo.

The sun had been leaning west, stretching the shadows of the goddesses, and as my shift wound down I began to grow restless – standing, sitting, and standing again.

'I'll be back next week.'

'I look forward to it.'

'So—'

So . . . what? Was I hoping to have sex again? I scanned the room in search of words, a place to pin my hopes. The other goddesses chatted gaily in ancient Greek and Old French, making the most of their weekly holiday.

'Don't worry. I'll be here, unfortunately. With more certainty than you.'

That was true. Unlike me, there was little possibility of her catching the virus that was going around, or getting into a car accident. No chance of her leaving her pedestal.

As I headed for the exit, I turned back several times, meeting her gaze. I nodded, and her shapely chin dipped in return. After that visit I clung to the sweet word fragments spoken by those white lips. Carried them around like a talisman.

Now, according to weather reports, the dreary rainy season had officially started the previous week. And with the June rains came a cruel humidity that made me shiver in the night. I crawled into bed and wrapped myself in my blanket and raincoat. I didn't know what I wanted from her. I just needed her to make me one outrageous, unthinkable promise.

*

I wonder when I learned that 'curators' did more than sit in the dark in their museums. Not that the knowledge helped me understand them any better. Who were these people who preferred statues over humans?

On Monday afternoon, I arrived at the back door and was about to call the usual number when the door opened. 'Welcome,' said Hashibami.

I instinctively looked away. His elegant hands and clothes made me think of that night in the gallery. Silently, I proceeded behind him, stepping on his shadow as I walked. He didn't seem to notice my modest show of rebellion as he strode towards the gallery of goddesses. The first sign that something was different came halfway up the grand staircase.

'Is it hot outside?'

I stopped. So did Hashibami. Conversations between us never consisted of more than: *Watch your step. Thank you. Will next week's shift work for you? Yes.* He'd never shown any interest in what was happening outside of the museum.

'No, the rain makes it feel cooler than it is,' I rasped, climbing two steps at a time.

'Is that so.'

As soon as I caught up, Hashibami started walking

again, as though he'd checked to see that his dog was keeping up.

As we passed through the upstairs hall, I heard someone chanting from one of the rooms. *Whenever it rains, one of the Buddha statues starts to chant, even in the middle of the night*, Venus once told me. *It's so creepy I've asked a few times for them to stop, but they won't listen. Probably why they can't find salvation.* I remembered her laugh and felt a rush of energy. I asked Hashibami, 'Was it raining when you came in today?'

'I live here. At the museum.' He shot me a look that could be interpreted as either uneasy or triumphant. Our eyes locked. We were standing in front of the gallery, and though I was staring into his face, I kept forgetting what he looked like. It all escaped me: eyes that reminded me of an intelligent dog, the magnificent ridge of his nose, his cheekbones, steep as cliffs. His features were positioned impeccably, yet I couldn't make sense of how they related to one another. One fact had taken over my mind – stretching out, as if it owned the place – and that was that he lived here. In the museum. He took out his key and unlocked the door, ushering me inside. From that moment on, I found myself burying my face in my hood every time Hashibami tried to strike up a conversation.

But he was persistent. The following week, he said in a single breath as soon as we were out of the gallery, 'May I ask for a little of your time today? I'd like to show you one of our other exhibitions. It's a great way to get to know this town.'

I felt slightly sorry for him. He'd been given the task of seducing me, after all, when really he had no interest. Just so he wouldn't have to let his goddess go.

He led me to the exhibition on the ground floor. I perused the exhibits that I'd already seen as though I were viewing them for the first time, pretending to study the historical landmarks of Kaizuka when my eyes were in fact glued to the back of his head. He wandered through the dimly lit gallery like a ghost haunting the museum. I realised then that I'd seen very few employees besides Hashibami here, not even cleaning staff. The building was old and the red carpeting and brass furniture well trodden, but the museum's interior was neither shabby nor musty with mildew. Not a fingerprint was to be found on the glass display cases. The maintenance was thorough, yet there were no other signs of human presence. In the mansion where time stood still, invisible fairies worked tirelessly for the owner ghost and his goddess statue.

'I'm done viewing the exhibition.'

'Terrific. What did you think?'

I thought about the clock hand artisans, the people who'd been replaced by machines. 'Whatever happened to them?'

Hashibami laughed shortly, reminding me again of that Thursday night. I stiffened inside my coat. Without addressing my question, he invited me to view the courtyard.

*

The courtyard was larger than I'd expected, and it was, surprisingly, a Japanese-themed space. We walked along the stone-paved path past a traditional rock garden, coming upon a pond where enormous koi carp swam leisurely. We crossed a red arched bridge from which I could see a classic teahouse, and further down, a waterfall cascading into the pond. By the time I came upon a mother duck with her ducklings, I'd lost all sense of direction, but Hashibami sped ahead. I concentrated on keeping up. He entered a covered rest area next to looming pine trees, and finally stopped to take a seat.

'This garden is really big,' I gasped as I joined him, drenched in sweat. Dust had gathered on the hem of my raincoat.

'Yes,' he replied, not the least bit out of breath. 'The millionaire who owned this building had a thing for gardens.'

'It's very well maintained,' I said, fanning my forehead. I noticed a tree branch behind him, stretching in my direction.

'It takes no small amount of effort and sacrifice to keep something looking beautiful,' he said, taking out a pair of scissors from his pocket and snipping the overgrown branch. He smiled. In the pond, a shockingly large koi chased its own tail, spinning in circles as though possessed.

'I wonder if they ever think about their own death. Or the death of loved ones,' he murmured.

'Sorry?'

'They're lucky if they don't.'

I took a seat, leaving a space open between us. My raincoat made an annoying rustling sound, while next to it, the sparkling leather shoes and the legs they were attached to uncrossed and crossed again. He opened his mouth. 'Have you got used to the job?'

'Yes.'

'That's good. We're lucky to have someone so proficient in Latin.'

'Oh, no.'

'I hear hardly anyone takes Latin in university

anymore. So to be able to converse in it is really something.'

I glanced over at him. His shapely fingers were drawing invisible patterns on the book in his lap, about a famous botanical garden overseas with a mission to protect endangered species. On the front cover, pink and yellow flowers bloomed as if their lives depended on it.

'Why did you learn Latin?'

'I learned,' he said, his fingers paused, 'so I could talk to Venus.'

His porcelain skin turned a shade of red.

'That's surprising,' I blurted out, then chose my words carefully. 'I don't think I've seen the two of you speaking very much.'

'Yes.' His fingers started to move again. 'You're probably right.'

'You learned an entire language for her?'

'It was a long time ago.'

'When—' I started to ask, but he cut me off.

'I wish I'd never learned.'

His fingers were now beginning to colour in the flowers on the cover. Or perhaps it was more accurate to say they were attacking the flowers like a torrential evening shower. Did the botanical garden, located at a higher latitude than where we were, have evening

rainstorms? Staring at the spinning carp, I tried to picture the workings of a thunderstorm. The dogged afternoon air thickened, becoming increasingly inept at bearing its own weight.

'Where words end, there is only despair,' Hashibami said slowly, as though he were trying to persuade someone. 'In the end, they will always expose our differences. Words help to build a bridge, but in the length of the bridge, we learn the distance to the other shore. That always saddens me. I find it almost unforgivable. Don't you feel that way too?'

'I . . .'

Grabbing my raincoat sleeves with both hands, I imagined the very first raindrop of a storm that plunges from the thick cumulonimbus cloud, only to vanish immediately. 'I don't really know yet.'

The family of ducks in the pond took flight at once, or so it seemed. Upon closer inspection, I saw that one had been left behind. The skinny duckling watched its mother and siblings for a while, then began poking at the water's surface as though nothing had happened.

Hashibami set the book on the bench and turned to me. *Here it comes*, I thought. 'Sorry, I went off on a tangent. There's something I'd like to ask you today. Would it be possible . . . just for a little while . . . for you to pretend you're attracted to me?'

I was stunned. He wasn't even going to attempt to seduce me or trick me into falling for him. He looked dead serious.

'I'm sorry, what do you mean?'

'Right. Of course. You have no idea what I'm talking about. How about if I offered to pay three times your current rate?' Hashibami's expression remained unchanged. Something was amiss with this person. I suddenly felt exhausted.

'Uh, I still don't understand.'

'You don't have to understand. If you can just do it.'

He looked as puzzled as I felt. As if he couldn't fathom why I wouldn't just accept his harmless suggestion when he'd offered to increase my pay. He addressed me as though I were a machine made of silicone, a machine programmed to react a specific way to the electronic signals he sent.

Hello.

How are you?

I love you.

My body grew heavy. The hem of my raincoat was fluttering wildly, as though it were lashing out at something.

'Anyway,' Hashibami said. 'Please think about it. You don't need to give me an answer right away.'

I stood up from the bench and took a few steps,

then left the courtyard without turning back. The koi never stopped spinning.

*

It was still light out when I returned to my apartment. I found the neighbour boy sitting in front of the door – *my* door – with his legs splayed out before him. I remembered the social worker who had paid the apartment a visit.

'I'm not making curry today,' I said, sounding more shrill than I'd intended.

He lifted his face. The faded orange sweatshirt had been replaced by a faded light blue T-shirt, and the gap I had once seen in his mouth was filled with new front teeth. He fished something out of his pocket.

'Here.'

It was a box of caramels. The boy got to his feet, but instead of going home, he ran down the stairs and off somewhere.

The box contained two black-and-white photo cards – one of the Great Wall of China, the other of Niagara Falls. The spray from the waterfall was frozen in time, as though enduring some kind of punishment.

*

Late June was a tough season for raincoat-wearers. The relentless humidity was made worse by the early summer heat, turning the inside of the coat into a miniature rainforest. My neck, back, and the insides of my elbows itched uncontrollably, and I felt something pop and ooze in the middle of the night from all the scratching. Wearily, I pulled my pyjama top up in front of the mirror and saw red blisters across my back, like wallpaper covered in tiny flowers. The next morning, I stopped by the dermatologist before work. I'd been going there for years and was prescribed my usual medication before I could even fold up my sleeves to show my elbows.

Late June was also rough on freezer workers. When I'd first started at the freezer and someone warned me that summers were harder than winters, I assumed they were joking. Now I knew. The difference between the freezer and the outdoors was upwards of forty degrees; fifty degrees as outside temperatures rose. Which wreaked havoc on our autonomic nervous systems, causing headaches and insomnia. Two employees were off sick this week. Ikeda approached me about taking on more shifts. 'I'm so glad we have you,' he said in his nasal voice, and before I could answer, he placed a few frozen

items in my hands that he had purchased with his employee discount.

When I finished my shift, I walked out into the early evening air, my body chilled to the bone, to find myself surrounded by noise and humidity. What an unpleasant world. I crawled onto the bus and switched on the air conditioner as soon as I got home, lowering the temperature a degree or two each day. I no longer had the energy to stop by the library. Seriko called me less often now that she had a carer, so after an early dinner, I would tune into random livestreams: a roadside station along a mountain road, a port in Portugal, a cable car platform in Argentina. In one Thai village, monkeys slept in a herd. I had poured a cup of tea and settled in to watch when one monkey stirred near the back of the group, stomped towards the camera, and covered the lens with a leaf. The monkeys were gone.

Out of the blue I thought of my old classmate Yuki, and I picked up my phone to search his name. Yuki, the boy who had reached over his balcony to mine. I remembered his name. Only his name. Up came a master's thesis on the genetics of four o'clock flowers, a corporate release about a shareholder meeting, a Facebook page with a years-old ski retreat group photo as its recent update. Scrolling through the lives of people

who shared his name, I realised I knew nothing about his likes and dislikes, about what he had dreamed of becoming – not a thing about him.

<p style="text-align:center">*</p>

Am I going to pay for this someday? For being a coward, for not going after what I want?

The one day of sunshine dropped into the damp rainy season felt like the preliminaries for summer. The dazzling reflection on the asphalt burned my eyes, puffy from the humidity of the previous day, and my ears wilted in the heat. But the museum was independent of all that misery. The harsher the outdoor conditions became, the stricter the control on the climate in the building. Day after day, the place appeared unaffected. When I stepped in through the back door a chill ran through my body, even under the raincoat, turning my eardrums numb. My interactions with Hashibami, who still walked slightly ahead, had returned to normal, as if our courtyard discussion had never occurred.

'Please watch your step.'

'Thank you.'

Venus, on the other hand, looked paler than usual, her alto voice a touch hoarse.

'First it's the humidity, then the sun beating down. And the AC is freezing. I'm about to lose it.'

'You do look a little tired today.'

She looked as though she'd aged several years.

'I haven't been sleeping well. I see why sleep deprivation is used to torture people. It's the same in every era. To think you can't escape who you are, not even for a moment. The horror.'

At some point, the steaming tea served in golden-vine-patterned teacups had been replaced by iced tea in clear glasses.

We discussed the other works in the museum but our conversation was halting, and as I gazed at the flood of light outside of the window while ice cubes tinkled in the glasses, I imagined I was looking down on Earth from another planet. Surrounded by silence so deafening that it hurt my ears, I hovered close to the surface of the grey planet, unable to catch gravity's attention. *I am all alone. I don't know how to get back down to Earth. Or if I even wish to.*

'Uh, I saw you and Hashibami together.' I didn't mean to blurt that out.

'Oh?' The goddess blinked slowly. 'What did you think?'

'I thought it was cruel.'

'You're right,' Venus replied, still smiling. If this

were a movie or a drama, she might shrug her shoulders or twirl her straw mindlessly. But she didn't budge from the neck down.

'Um, has it always been this way?'

'Do you mean Hashibami? It depends on what you mean by "this way", but he's always like that. He wants things to stay that way.'

For some reason, I was hurt that her expression remained fixed.

'And you're okay with that?'

'Of course I'm not okay with that. Would you be able to stand it? Not having anyone to talk to but a creepy curator; being leered at by strangers all day. Standing in this same stupid pose. My shoulders are so stiff.'

'Let's run away. To somewhere you can be free.'

I was surprised to hear the words leave my mouth, as if I'd planned them all along. I heard footsteps approach. Was it Hashibami?

I looked at Venus, hoping to meet her warm, pupilless eyes. But she closed them as though exhausted, and didn't open them again until the footsteps had passed. After a long pause, she asked in a kind voice, 'Hora, I want you to imagine something. What do you think is the scariest thing in the world?'

I replied without a beat, 'To not have you in it.'

Venus smiled and brushed my words aside. 'To

not have anything to wait for,' she said. 'People can get through the day because they have something to wait for. It can be big or small; something that might not even come to pass. It's the waiting that keeps them going. They wait to eat three times a day, wait for the weekend, wait for new classes, wait for their lovers to arrive, wait to graduate, wait to be transferred, find a new job, retire. They wait to sleep. And finally, they wait to die.'

She spoke like a teacher explaining simple sentence structure.

'I waited at first too. And they came. Lots of people. And then they went.'

'They went?'

She smiled and thought for a moment, as though she'd been asked an unexpected but not too challenging question by a student.

'You see us in front of the station and in parks, don't you? Statues of dogs and naked women. People make promises to meet up in front of me, and when they find each other, they leave. But me? I can't go anywhere. All I can do is welcome everyone with a smile. I have so much time on my hands, I could probably write a whole book of poems, if I had the talent. Then again, I don't have hands to write them down. I also speak a language no one understands.'

'I do,' I sputtered, but my voice rang empty. Melting along with the ice in my glass.

'I look forward to seeing you, Hora, more than anyone. But you too will die. The more I yearn for you, the sooner you will die. There's no getting around that. If you really want to help me, I want you to push me off this pedestal and finish me off before you die. Even though . . .' Venus let out a short breath. 'You didn't help me that day.'

'You knew?'

'You refuse to go out on a limb if you think you might get hurt. That's why you push people away. That's why you push *yourself* away.'

As her words rolled over the surface of the planet, piece by piece, I imagined a wind starting to blow – fiery gusts with a high concentration of carbon dioxide and sulphur. I shrank inside my raincoat, wishing for once that the yellow vinyl were thicker. So thick that no heat or sound could penetrate it. I wished I could take shelter under my coat for eternity, while also hoping the hot winds would tear the fabric and blow my contours away. Everything would go then. My green peekaboo highlights; my groove, which suffered from constant thirst. I would become a part of this planet. There would be no room for loneliness, and I would be happy.

'Hora,' Venus whispered.

How I wished it was just us in a hotel room watching the sun rise. In a bed together, midway through our travels somewhere. Today, off to the Great Wall of China. Tomorrow, Salar de Uyuni.

'I can't bear to wait anymore,' she said. 'I mean, look. Even when we're trying to have a serious conversation, I can't lower the corners of my mouth.'

I saw her carved smile and silently cancelled our flight to Bolivia.

Hashibami appeared at the gallery door.

'Have a great life, Hora. Your party has arrived,' Venus said, dropping her gaze to the floor. I pretended not to notice, but there was a tremble in her voice that I couldn't ignore. I waved to the other goddesses and exited the room. The orange afternoon sky glimmered through the skylight, celebrating the end of rainy season and the arrival of summer. The season that never ends, like an unwelcome house guest that refuses to leave.

*

The museum hallway was thick with secret sounds. A period instrument quartet with too much time on their hands, the shiver of trilobite fossils and coral yearning for the sea, the stir of extinct-bird

skeleton specimens. The curator strode happily down the hall, revelling in each sound. I vaguely remembered him saying that this was his home.

After a while, he turned. He didn't try to hide his impatience as I stood and listened to the gallery sounds.

'I hope you don't misunderstand me. This is what's best for her. She can't leave this place. And she'll be better off accepting that fact. Also—'

I braced myself, though not quickly enough. He continued.

'What will you do if she really does go free? If her pedestal vanishes one day? Won't that be hard? I'm talking about the most common and natural of human emotions here. You want your loved one to be happy. But only if they stay within your reach. That's normal. Don't you agree?'

*

That night, I took a bath and went to bed early, like when a cold is coming on. Lying in bed, I heard the faint sound of a radio next door. It wasn't the boy's apartment, but the one with the resident I never saw. The radio programme was beginner-level Portuguese. Today's main phrase was: *May I try this on?*

'Are you sick? Do you need an ice pack?' Seriko timidly came up the stairs to see how I was doing. She carried an armload of handmade mugwort cold packs.

'I'm okay, just a little tired.'

'Are you sure?'

Unfortunately, I was.

Next door, the Portuguese lesson ended and a high-school-level sociology lesson began. I listened to an explanation of basic human rights, hoping to grow drowsy. My body objected to resting so early, however, and I opened up a random livestream on my phone. But the onscreen noise was so amplified in the darkened room that I clicked off immediately. It had started to rain, and lukewarm humidity wafted through the poorly installed windows and slithered between my skin and raincoat.

A snail. I clamped my eyes shut and pictured a snail travelling slowly on a hydrangea leaf. Inching forward in the dark, the snail could not distinguish colours or shapes. Emitting mucus that resembled an aurora, it crept along cautiously so as not to damage its own fragile skin. Fortunately, it did not have to fear drying up in the sun or being attacked by pea-brained birds at night.

The snail had a shell that swirled counterclockwise, which is rare for the species. But it made

the snail feel safe, because it knew that regular snails can't mate with opposite-swirl snails. Mating. The snail had heard about mating. Something to do with shooting darts – they're actually called love darts – at each other, which sometimes ended in the loss of a life. Love darts! The snail shuddered at the possibility – both of dying an excruciating death and of killing someone else. Which was why the snail was grateful not to have to encounter another left-swirl snail. The sky was starting to brighten. Snail eyes can only sense light, which now overflowed. At a furious speed.

And then, I woke up. Not by choice. I was all tangled up in my raincoat and blanket.

*

One employee quit the warehouse after less than a month, and others frequently called in sick, which meant I was being asked to come in nearly every day. My body was now frozen to its core, and also feverish all the time. I slept non-stop when I was home.

The raincoat was thicker than I'd ever felt it, and hard as a used rubber glove. Parts of my heat rash had blistered, and when I towelled off after a shower,

I noticed a large pus-filled bump in my groin area. I pressed on it using the nails of both forefingers. As I moved my nails around the lump swollen with yellowish-green fluid, it puffed up like a nasty slime mould and burst, bleeding slightly. I dabbed at it with disinfectant-sprayed tissue.

*

I had another dream. I was standing in front of a museum – a much more extravagant one than the one where Venus lived. I entered through a magnificent gate adorned with floral sculptures, and trod up the path to the main entrance, through a lavish garden that swept across the front. There were plants shaped like rabbits and elephants, and a spectacular water fountain. When I reached the brick entrance, the heavy door opened without a sound.

The spacious hall on the ground floor teemed with activity. The exhibitions featured taxidermy and fluid-preserved specimens: a unicorn horn discovered in Romania, a bronze-hued mermaid mummy, the liver of a white dragon. Visitors walked around the hall in a daze, staring at the exhibits of rare and unusual beasts from past and present. The guests' faces were shrouded in a pale pink haze that

occasionally expelled small bolts of lightning, as if warning of some danger. But no one reacted; they simply continued exchanging heated opinions on the specimens, writing down notes, floating through the gallery.

The upstairs exhibition, in contrast, was empty and cold. Human beings of all backgrounds were on display. Frozen. There was a frozen primary school student, a frozen company board member, a frozen friendly old man. They were not frozen *over*, apparently. Though pale and slightly tired-looking, they did not seem uncomfortable as they moved leisurely inside the glass display cases, which had been processed to keep them from frosting over. Some of them even waved. The thin layer of ice that had formed at their feet and on their clothes cracked and crunched.

Soon I heard the same sound come from my own collar.

'So beautiful.'

There was Hashibami, smiling on the other side of the glass. I'd become part of the exhibition. The chill wrapped around me gently as I tried to stretch out my limp arms. Hashibami applauded loudly and was joined by the person next to him, and the person next to them. Ikeda from work was also present. I wanted

to say thank you for coming, but my voice froze and sent my words tumbling to the ground. Ikeda pointed to his throat and gave me a troubled smile. As I watched him make the familiar gesture, I stopped worrying about having lost my voice. With each passing day, fewer people were there to applaud us, until there was no one to look at me at all. But I no longer cared. Crack, crunch, crush.

Next thing I knew, I was in the freezer. On the very top shelf I'd come to know so well. Employees in matching thermal jackets roamed back and forth with their pick lists, retrieving products from the shelves and piling them onto dollies. I spotted someone in a bright yellow raincoat and felt I knew them personally. The person headed towards me with their pick list and stared up at my shelf for a long time before reaching for the item next to me – the *Imperfect Ningyo-Yaki Cakes (Red Bean Paste)*. The item was placed on the dolly and transported away. The person never turned around.

I felt a rush of relief as the person strode off. This was what I'd yearned for all along. I'd been desperate for this freedom. Free from desiring someone, from being me. A light crackling sound tickled my ear. I was starting to freeze over.

My heart fell when I realised I'd been dreaming. A truck roared past down the street, shaking the apartment.

*

There weren't many advantages to wearing a raincoat that could never be taken off, but at least I could avoid getting rained on.

I came home that day without an umbrella. The sky had looked bright and clear from the bus, and besides, it was too crowded for me to rummage through my backpack for my collapsible umbrella. But the moment I stepped off the bus, a lukewarm wind whirled and the sky opened up to unfurl raindrops that felt like pellets and blew into my hood without mercy.

So I felt a little sheepish when I ran into the neighbour boy at the apartment building entrance. He was sitting under the mailboxes, lining up small vinyl figurines between his outstretched legs like he was lecturing his little brothers for being naughty. He looked stunned to see me. I gave a small nod and started to walk past him, until I noticed he was barefoot.

'Are you locked out?' I asked, wondering if my voice would reach him.

He nodded. The rain was pelting the ground just a few inches past his toes.

I didn't know what to do. If I let him into my apartment to wait out the rain, would his mother accuse me of kidnapping? More importantly, what would the boy and I talk about? As he eyed me quizzically for not following up my question, a window opened nearby.

'Oh, it's you two.'

The smell of onions drifted out. Of course.

'My, it's pouring. How about dinner?'

*

Seriko welcomed us in, though neither of us could reciprocate her enthusiasm.

'Oh my, oh my, what do small children eat?' she said, peering merrily into the fridge, scuttling to and from the stove. I offered to help but it was refused, and because I had nothing else to do, I figured I would tidy up the room. Thanks to her hired carers, however, it was already neat. In the absence of clutter, Seriko's apartment had almost no furniture. All that remained besides her small TV, dining table, and bed was her

half-finished patchwork project and a few volumes of poetry.

The boy, whose name was Tohma, sat on one of Seriko's handmade cushions and watched television, though *watched* might be an overstatement. Let's just say his eyes were not closed. The evening news featured a segment on parakeets that were mating at an exponential rate and starting to go wild. A woman whose dog had been attacked by a parakeet ranted to the camera about how ferocious the bird had been.

The rain came pounding down outside as our humble dinner party began. Leftover hijiki-seaweed-filled meatballs were tossed into some spaghetti sauce, and simmered kabocha squash had been converted into pumpkin soup, both of which now sat steaming on the table. I hadn't had a home-cooked meal with no frozen foods in some time. I fearfully placed my spoon in the soup and scooped up vegetables of all shapes and sizes.

'This is good.' The words in my head found their way out of my mouth.

'I was cook before,' Seriko said, scratching her cheek. If you chopped and sautéed onions beforehand, she said, it made cooking easier.

Seriko did most of the talking. Or questioning.

'What grade are you?'

'Third.'

'Goodness, fifth grade.'

The boy didn't correct her and continued to eat.

'What's your favourite school lunch?'

'Miso-flavoured udon with chicken and kabocha in it.'

'It's good?'

'It keeps me full.'

That last comment must have been what did it. Once dinner was over, Seriko insisted on getting desserts for Tohma, and she left in the rain to go to the supermarket. I was left behind with the boy. We both stared at the TV.

Tohma sat unmoving, following what was on the screen with his eyes. I thought he looked like some kind of monk-in-training. Under his long eyelashes, his pupils collected a staggering amount of light as the moving pictures washed over them. The white skirts of pop idols on a music show, the interest-rate graphs in a commercial for a consumer loan company. Appearing, disappearing.

'Do you always wear that?' Tohma said when one show transitioned into another, this one featuring a bright neon set with bleacher-style seating, like a tasteless Hinamatsuri festival.

'That?'

'The yellow thing. Is it a raincoat?'

'You can see it?' I blurted out.

The boy nodded without taking his eyes off the screen. TV personalities donning school uniforms sat in rows and gave off-the-wall answers to trivia questions.

'This raincoat? Really?'

'Everyone wears something. All adults do. I've never seen anything as bright as yours though. Usually it's a mask or a T-shirt, or sunglasses and gloves, and it's like, blurry. The old lady who lives here wears earmuffs.'

'Earmuffs.'

'They're fluffy. Furry. Looks like fur. This show's dumb,' he said, flicking the TV off with the remote.

'Um, so . . .' I tried to organise my thoughts. According to Tohma, everyone wore some type of extra garment, and for Seriko, it was earmuffs? I didn't know why I thought that sounded exactly right.

'Do people know they're wearing . . . whatever?'

'I've never asked,' he said, and sneezed once. 'But they just go on with their lives so maybe it doesn't bother them. I think it's hard for people with earmuffs and masks to talk, though.'

'Yeah, I have no idea what Seriko's saying sometimes.'

'But isn't everyone like that? Everyone's sort of off. But somehow they deal with it. Like how you're talking to me, even with that hood on.'

Tohma blew his nose with a used tissue that he took out of his khakis. I passed him the tissue box on the dining table, wondering if I should tell him to take it home. Seriko stocked up on toilet paper and tissue, and I knew she had at least two dozen boxes in the closet. If the carer hadn't thrown them out, that is.

I had so many more questions for Tohma, but after blowing his nose, he closed his eyes as though he were an electronic device being charged. I grew worried. Was it okay to keep a human this small up so late at night?

'Are you okay? Do you want to go home?' I didn't mean to ask more questions.

'I'm okay. It's still eight o'clock or something, right? I can't get into my house.'

I was wondering whether it was appropriate to ask why he couldn't get into his house when he said, his eyes still closed, 'Won't you be sad without your yellow thing? I see how people use it and it looks helpful. It keeps bugs away, or it's like a blanket they can share with people. Besides, you can't just take it off and leave it, right?'

In lieu of a reply, I stood and closed the window. I could still hear the sound of the rain.

*

When Seriko came home, her slacks were soaked to the knees, as though she'd waded through a river. But she didn't seem bothered as she laid out the food items she had purchased.

'I have castella. And yoghurt jelly. Which would you like? Both? Oh, I also have watermelon ice cream. And where's that cream anmitsu . . .'

She reminded me of a grandmother doting on her grandchild. Did Seriko have grandchildren? Or children? She was always just 'Seriko' to me.

Tohma hesitated at first, then grabbed his dessert of choice. As he ate, he answered Seriko's rapid-fire questions.

'Does your school have English classes?'

'Yes.'

'Can you say something?'

'*You are a singer,*' he said in English.

'Huh? *Shin-ga?*'

'It means you're someone who sings.'

'A singer? Oh my! I used to learn nagauta.'

'Nagauta? What's that?'

With every question and answer, every round trip of the spoon, the room began to expand and grow. Everything from Seriko's droning voice to Tohma's long eyelashes to the array of half-eaten sweets on the table to the floral kitchen tiles to the yellowed walls after years of frying with cooking oil. I closed my eyes so I could remember it all, so that none of it spilled out of my memory. They were all ordinary things, yet their presence felt elusive, like they could all disappear without a moment's notice. Everything had a place to return to.

I remembered a word then. *Partior* (to divide up). We in this small party were separate beings with no hope of becoming one. Which is why we were able to assemble in the first place. Why we attempted to connect with one another, however awkwardly, fearfully, or in purposely indelicate ways.

'Why can't you get into your house? I see you out in the hall sometimes,' I finally asked Tohma, after debating it in my mind. Seriko had stood to prepare a fresh pot of tea. He was eating a sugar-coated doughnut and licking his fingers, looking like a monk-in-training who'd snuck out of the monastery.

'I forget my key a lot.'

'Can't someone let you in?'

'No, my mom's at work. My dad doesn't know where we live,' he said, and then his eyes flashed with fear. 'Don't tell anyone, okay? My dad told me the only reason I was born is because he didn't let Mom have an operation and I should be grateful, and that makes Mom really mad. That's what makes her hit things.'

'Okay, I won't say anything. Is there anything else that you need? Besides your key?'

Tohma thought for a while, then took a small object out of his pocket. 'Can you fix this? We don't have glue at home.'

He held out one of the figurines I'd seen him playing with earlier, one of the little brothers. It was a half-boy, half-cat character in blue overalls whose arm was barely hanging on. I borrowed Seriko's glue and walked under the hallway lamp as I searched online for the character's signature pose so I could glue his arm on right. I waited for the adhesive to dry, then returned to the living room to find Tohma curled up on the floor. Like a resting mound of bread dough.

I tiptoed towards him and squatted to return the figurine to his pocket where the other brothers slept, when his soft fingers reached out and grabbed my arm. My raincoat rustled. The touch lasted no

more than a second, but the moist warmth of his fingertips rendered me immobile. I could be the recipient of this warmth from others, if only I allowed it. As long as I remembered that nothing lasts forever.

The party came to an abrupt end. As Seriko was preparing to serve her tea, the click-clack of high heels sounded on the stairs, and at the top, a key turned in the door. Tohma's eyes popped open, and he stood. 'I'm gonna go. Thank you for the food.'

On his way out, he whispered in my ear as if to share a secret.

'Did you know a sea lion lives in Apartment Three? I saw him turn into a human the other day, in the hallway. He had a suit on, and he was holding a Portuguese textbook.'

At the door, Seriko gave us each a patchwork bag. 'It's to carry onions.' I looked down. Instead of a well-ventilated sack that was suitable for carrying vegetables, I was looking at a frumpy-looking thing made of thick, bulky cloth. It was big enough to fit a gigantic dog. I carried it up the stairs, glancing at the bridge on the way. I couldn't make anything out in the dark.

*

That night in bed, my mind wandered as I started to doze off. I pictured a thin needle and a strand of thread. The needle and thread sat at the edge of a bed, contemplating what to make for the boy who was tossing and turning under the covers, trying to duck the moonlight that streamed in through his window. A pair of scissors joined them.

After deliberating for some time, the tools reached a consensus, took their positions, and got to work. They would sew a shirt out of translucent cloth. It would have to be perfect for the boy, but the expert tools could make anything – shirts, sweaters, eyeglasses. If necessary, they would put in an order for invisible yarn and lenses. Often they ordered more than they needed because it was more economical that way. They would eventually use it all. They, meaning both the tools and the humans for whom they were creating the garments. At about two in the morning, the tools took a break and poured some tea that sparkled under the stars.

The shirt was completed shortly before sunrise. Wiping away beads of sweat, the tools stared breathlessly at the pristine new garment. It was perfect for the young boy, a shirt dyed a brilliant yellow. They helped the sleeping boy into the garment, calling out

his name as they worked. But soon they remembered he could not hear as clearly as before. So instead, they prayed. That the shirt would protect the boy, that he'd be able to bear the trade-off. The tension in the air eased. The prayer was the finishing touch. With the arrival of dawn, the bright yellow colour faded, leaving only the presence of the shirt. The tools nodded in satisfaction and were on their way, and the boy turned over in bed in his new shirt.

He would awaken after a few rounds of his alarm, and when he walked into the kitchen for a glass of water, he would notice. The stiffness of the unseen buttons, the tone of his own voice, which sounded different from the day before.

*

Venus saw me enter the gallery alone and shot me a bewildered look.

'You came? After our last conversation?'

'Yes, I came.'

I closed the door behind me. My usual chair was nowhere to be seen. I set my things down and readjusted my hood. The sun was out, but a lukewarm wind blew violently, propelling the clouds above the

skylight from right to left like out-of-control hot-air balloons.

Sneaking into the museum had been easier than expected. I'd arrived earlier than usual and set off the fire alarm. When Hashibami rushed out of the back door to see what the commotion was about, I struck him over the head with the fire extinguisher and snatched his keys. I'd watched several videos on how to knock someone out with a fire extinguisher, but it was much heavier than I'd expected, and I didn't hit him so much as hurl the thing in his general direction. I was surprised by how easily he toppled over. The problem with this strategy was that once he gathered himself, he would come after me. Enraged.

Which was why I had to hurry. I made a small barricade in front of the gallery door, piling up my dictionary, thermos, and anything else I'd brought with me. I opened my backpack to pull out the item I'd stuffed inside. Even with stiff fingers, the zipper slid open as if it had been waiting for this moment.

'Venus, please. I need you to get inside this bag.'

'Hora, what are you saying? What *is* that?'

'An onion bag. My landlady gave it to me.'

'What do you *mean*? I have no idea what you mean.'

'I don't know either. It's the weirdest thing,' I said as I unfolded the stepladder and lifted myself up to the surveillance camera in the corner of the room. My raincoat hem fluttered. I couldn't believe how efficiently my body moved. As I reached out to touch the lustreless black device, I thought again: *It's the strangest thing.* I felt no discomfort. I didn't want to howl with laughter, but I also didn't feel the need to keep a straight face. I felt the way one might when they've discovered a lovely stamp on a letter that has arrived unexpectedly in the mail.

As I made my preparations, I could sense Venus's trepidation. Even if she was still smiling.

'Hora, stop. I don't know what you're doing, but it's not too late to stop, is it?'

'Oh, it's definitely too late. After this, I'll never be able to set foot in here again.'

A tepid breeze grazed my neck, and I glanced at the window. It was usually clamped shut like a clam, but was open a crack today. Had Hashibami been planning to do something? Maybe I should abort my plan, I thought. But I decided to forget about him. I wouldn't let his circumstances dictate my next move. I glanced up at Venus.

'I can't do this without your approval, of course. I'm just setting the stage. For you to be free.'

'And I'm grateful to you for that, but there's just no way. I can't leave the museum. I could never live outside these walls.'

'But are you really living now? Listen to me. What you need isn't a good night's sleep to escape your reality, it's to go somewhere where you can be one hundred per cent awake.'

Her eyebrow-less eyes bore into me, feverish and turbulent, like gusts of wind before a typhoon. She turned away.

'But you . . . never mind,' she said.

'People say "never mind" when there's something to mind.'

'It's nothing, I promise.'

'You're lying.'

With every retort our voices rose a few decibels, and I could sense the other goddesses – who couldn't understand Latin – growing excited. Lady Hera whispered something to Minerva, goddess of wisdom, and shot us a glare, and the dog next to Artemis, goddess of the hunt, barked furiously, fluttering that ear again. Amid the confusion, the clouds above blew at a dizzying speed as the sky turned a yellowish-green hue, like a knee bruise that was nearly healed.

'But Hora . . .'

I waited. To hear words spoken in a once-universal

language now on the brink of death. For the voice that had taught me the joy of yearning, and the pain of pining.

Tap, tap, tap. Footsteps approached in the hallway.

'You're going to leave me someday too,' the goddess said.

Tap, tap, tap, tap. The footsteps were quicker now.

I rushed to scoop up her words, catching them before they spilled.

'If you ask me to, I'll take a hammer and break you into a million pieces right now. Or I can throw you into the ocean. I'll find a way to live with the loneliness. That's a hundred times better than tying someone down. So what do you—'

Tap, tap, tap, tap.

The door was flung open, and I turned to see Hashibami hovering over the barricade. The first thing he did was gape at the patchwork onion bag. He then looked at the surveillance camera, which was pointed directly at the ceiling. And finally, his eyes landed on Venus and me. His chiselled features were red and splotchy.

'What are you doing?'

'We're talking,' I replied. 'Something you don't seem to be very good at.'

I turned to Venus and repeated what I'd said in

Latin. 'Let's speak Latin,' I suggested to Hashibami, but my words didn't seem to reach him.

'I can see that's what you're doing,' he retorted in Japanese. *Then why'd you ask*, I thought, as I translated what he'd said. Venus was staring off into the distance. Her side profile looked as though it wished to return to a time when she was just a slab of marble. Before she'd become affiliated with any myths.

'I apologise if this sounds rude, but I underestimated you. I was fooled by your demeanour, which had me believing you were someone without a mind of her own.'

'I'm impressed by the things that come out of your mouth.' My words flowed. I wasn't gasping for air like usual.

Hashibami stepped over the barricade and approached us slowly. The other goddesses had gone silent.

'Please, come this way. It's not too late to be forgiven. For attempting to remove a work of art from the museum, for assaulting me with your bag.'

'It wasn't a bag, it was a fire extinguisher.'

'Who cares about . . . *ow!*' he yelped.

Artemis's hunting dog had bitten his left arm, her ear wagging furiously. This surprised even Artemis, who looked from Hashibami to her dog several times

before finally hollering something in ancient Greek or Old French. I couldn't understand her, but the other goddesses joined in and started to yell themselves.

'Argh, damn dog!'

Hashibami looked stunned by the howls of the goddesses, which he'd never heard before, and he tried to shake the dog off before remembering that the animal too was a work of art. He took out his white gloves but couldn't get them on.

I whispered to Venus, 'Let's go.'

'Okay.'

I unfolded the dolly that I'd borrowed from the warehouse and set up the onion bag. Through it all, the goddesses continued to yell. Daphne was particularly vocal. In her myth, she was pursued by Apollo and continually refused his advances but had nowhere to run and finally turned herself into a laurel tree. She now screamed over and over in English, 'Go to hell!'

I'd stepped away from Venus for just a moment when it happened. As I rummaged through my backpack for my own gloves, my vision dimmed. I turned around to see the dog with bubble wrap stuffed in its mouth, and Hashibami, standing menacingly between Venus and me.

'I'm going to say this one more time,' he panted,

his face now white, as though he could fade out of sight at any moment. 'It's not too late to be forgiven. Fortunately, you've not yet laid a finger on Venus. You just need to promise that you will never enter this museum again.'

'Please speak Latin. So Venus can understand you.'

A strong gust blew the window open then, letting in a block of humid air. Distracted for a moment, Hashibami and I fixed our gazes on each other again.

'Fine. Aphrodite, you understand me, right?' He turned towards Venus and said in a pained voice, 'I'm saying this for you. The world is a dangerous place. You're not aware of issues around temperature and humidity, the possibility of theft. Have you considered that?'

Venus listened without a word, her white eyes void of emotion. Hashibami took advantage of her silence and kept going. 'You're right that this environment is unique. If you're lonely, I can find you another conversation partner. Listen to me. You are a magnificent, beautiful being that deserves to live for eternity. I won't let anyone take anything away from you, as long as you stay here.'

'Lonely? You're the one who's lonely.' Her voice was cold and hard as a rock. 'You're the one who can't

leave this place behind. You can only live within these walls, bound by your own rules.'

'What is happening to you? Why are you suddenly so serious?' Hashibami rasped.

'I've always been serious. You're the one who's not serious. First of all, stop being overly dramatic. You sound like an idiot. And what makes you think you can decide what beauty is?'

The hunting dog spit out the bubble wrap and resumed barking. The wind picked up outside.

'How can you say that? I've stood by your side for years, decades even, protecting you.'

'You always say "I do this for you" and "I love you", as if that makes everything right. Aren't you embarrassed? Ugh, cringe. Cringe! You make me so cold. I need a coat.'

'What are you saying? This place is all you know.'

Hashibami was floundering. He started to fumble around in his pocket, removing a pencil, a tape measure, a utility knife, a loupe, a dusting brush. The tools fell to the floor and rolled away.

'And give me a break about taking nothing away from me. I am robbed every single day. Robbed of my name, my body, my freedom,' Venus railed, swaying slightly, forwards and backwards.

'Venus, let's go. You don't have to bear the burden

of "forever". Let's just go as far as we can go, try to live as long as we can. We'll live quietly, however we want, however *you* want.' As I reached for her, Hashibami lunged at me with the utility knife.

How long had she been planning it? The timing was impeccable. A gust of wind blew into the gallery and swept the curtain into the air, and as Hashibami raised his knife, Venus gathered up momentum, and suddenly, she leapt. Kicking off the pedestal with her left foot.

'Goodbye, lonely boy.'

I closed my eyes tight.

But the sound I feared never came. The silence numbed my eardrums, and when I could bear it no longer, I cracked my eyes open.

A piece of yellow cloth was floating over the pedestal, flapping in the wind as if to soothe a crying baby. I approached it with trepidation. Hashibami was glued to the floor, and the goddesses all held their breath, and their poses. The tacky yellow colour stuck out like a sore thumb in the pristine gallery. I reached for the familiar synthetic fabric and softly lowered the hood.

'Can you hear me?'

'... Hora?'

She still didn't have eyelashes. Or pupils. But her

eyes locked onto mine. Her mouth, which until now had been distorted with worry, now lifted at the sides as if she'd just had a fun thought.

'I wonder if this is the last time I'll ever hear this.'

It took me a minute to realise she was talking about 'Auld Lang Syne', which had begun to play over the loudspeakers. I nodded and reached out my hand once more. The yellow raincoat made an irritating rustling sound. I noticed my own body felt lighter.

We left Hashibami gaping on the ground as we prepared to depart.

'What do you want to do once we're outside?'

'I don't know . . . Hmm, okay, I know this is clichéd, but I'd love to go clothes shopping.'

'Great idea. What kind of clothes?'

'Well, I think I'd look good in black. Because of my classic features.'

Disorder erupted outside the gallery. Were there other employees in the museum besides Hashibami? I clucked my tongue and looked at Venus, then put one foot on the dolly.

'Here we go.'

I couldn't hear her reply.

The sky looked stormier than before. A small white object – a bird or a hat – was being blown around in the distance. I ignored the pounding outside the room

and stretched out my hand to touch the skin I'd been pining so long for.

The first person I ever held with my own two arms. She was precious. And heavy. Like a bulk of rock.

Someone was screaming my name. My spine made a strange creaking noise as I pushed, and as I listened to the succession of sounds, my field of vision was flooded with light.

That day, I spotted a former student of mine. It was early morning at the boarding gate for a flight to Mexico City. Outside of the thick glass window on that clear Monday morning, magnificent steel birds were taking off into the sky. I had taken a sabbatical from the university where I'd worked for years, to visit fellow researchers and libraries abroad. I was feeling on top of the world.

Her luggage was the first thing to catch my eye. It was a rather dowdy, though colourful, patchwork object that could only be described as 'a very big bag'. She didn't appear to be carrying a pet or an instrument, nothing of that nature. She placed the bag on an industrial-looking cart and steered it towards a wall, carefully securing the brakes to keep it from rolling away. She then sat on the sofa next to it and opened the paper bag in her arms, taking out a drink and a doughnut. The cool air of the lobby filled with the sugary

aroma of fried sweets, and as I watched her indulge in the doughnut and lick the brown sugar off her fingers, I began to crave one myself. I made a mental note to pick one up before boarding.

Seeing her surprised me. I was of course generally surprised when I ran into someone I knew, especially if it was a student, though we usually had nothing to say besides 'What a surprise' and 'It's such a surprise!' But I was stunned by her transformation.

My first encounter with her had been in my Conversational Latin course. My first impression had been that she was . . . far away. It might have had something to do with her blank face or her muted clothing, but I just couldn't seem to *reach* her. She was right in front of me, and yet I had to holler as though she were on the other shore. Since I was the teacher, I'd naturally had to initiate the conversation. I'd tried to take attendance but couldn't make out her response. I'd stepped down from the podium and walked closer, and closer, until I was two seats away, before I finally heard a faint *Here*.

Her expression was much brighter now. Her eyes sparkled with anticipation as she peered into her device, and I noticed that sections of her hair were dyed a bright colour. Every so often, she spoke cheerfully into her tablet.

She'd been talkative back then too, as long as we were speaking Latin. That class was a bit silly in that we were holding conversations in a language that was nearly extinct. I'd begin the class by going over grammar points and trivia, but every time I made an attempt at humour, she looked down as though she didn't know how to respond. One day, she raised concerns about my health, and I decided to alter the course content. From there, we simply talked. She had a knack for the language. She was more articulate in Latin than any linguistic researcher I had met before. For her the language appeared to be more than a mere academic subject. She spoke with the passion of a minority group that had been prohibited from speaking their native tongue in public.

How she had come to speak the language remained a mystery. I asked her about it once, but she'd just replied, 'I studied abroad.' Nothing more. I couldn't think of a single school overseas with a programme that could help one become as fluent as her in the language. I'd hoped she would continue her studies in graduate school, but when I gathered up the courage to ask about her post-university plans, she'd replied that she wanted to work in a freezer and walked away. I didn't know what she meant.

After she graduated, I never taught the class again.

But when a museum reached out, asking me to recommend someone who could speak Latin, I thought of her immediately, though she'd long since left school. The curator on the phone had a condescending tone, if I recall. Maybe I'd ask her how the job went.

I stretched my back, which was stiff from the long bus ride to the airport, and glanced her way again. She appeared to be editing videos on her tablet, but her earphones must have been glitching as I could hear pieces of her conversation. Surprisingly, the conversation was in Latin.

Turn right at the Baths of Nero and go straight.
What time are the gladiators scheduled to appear?

Listening to sentences being spoken slowly and clearly, I thought that perhaps she had become a Latin teacher. A thought that filled me with joy. Though I couldn't think of an instance in which one might need to know those lines.

I heard another voice, a woman speaking much more rapidly than the first voice.

'Hi guys, it's Athena! Hope you're having a great morning. Thanks for watching in museums all over the world. I'm here today to share my morning routine with you!'

As bossa nova music started playing in the background, my former student seemed to realise that

those around her could hear. She rushed to turn off the sound and scanned the room. As the boarding announcements came over the loudspeakers, I stood up to go and say hello. I decided to forgo the doughnut. As I drew closer, she seemed to be speaking excitedly to the patchwork object next to her. I saw a flash of yellow in a nearby window.

'Okay, we're going to board soon.'

Was I imagining things, or did I hear the patchwork reply?

'Do you think we can visit Teotihuacan on the third day, or is that too much, schedule-wise?'

The voice was rather husky. Somewhere between a mezzo-soprano and an alto, though leaning more towards alto if I had to choose. If she were singing in a choir, that is.

Emi Yagi is an editor at a women's magazine in Japan. She was born in 1988 and lives in Tokyo. Her first novel and international cult hit, *Diary of a Void*, won the Osamu Dazai Prize, awarded annually to the best debut work of fiction.

Yuki Tejima is the translator of Mizuki Tsujimura's *Lost Souls Meet Under a Full Moon* and *How to Hold Someone in Your Heart*, Kumi Kimura's *Someone to Watch Over You*, and the sequel to Tetsuko Kuroyanagi's bestselling memoir, *Totto-chan: The Little Girl at the Window 2*. She moved from the US to Tokyo, where she now lives.